Summary Catalogue of European Sculpture

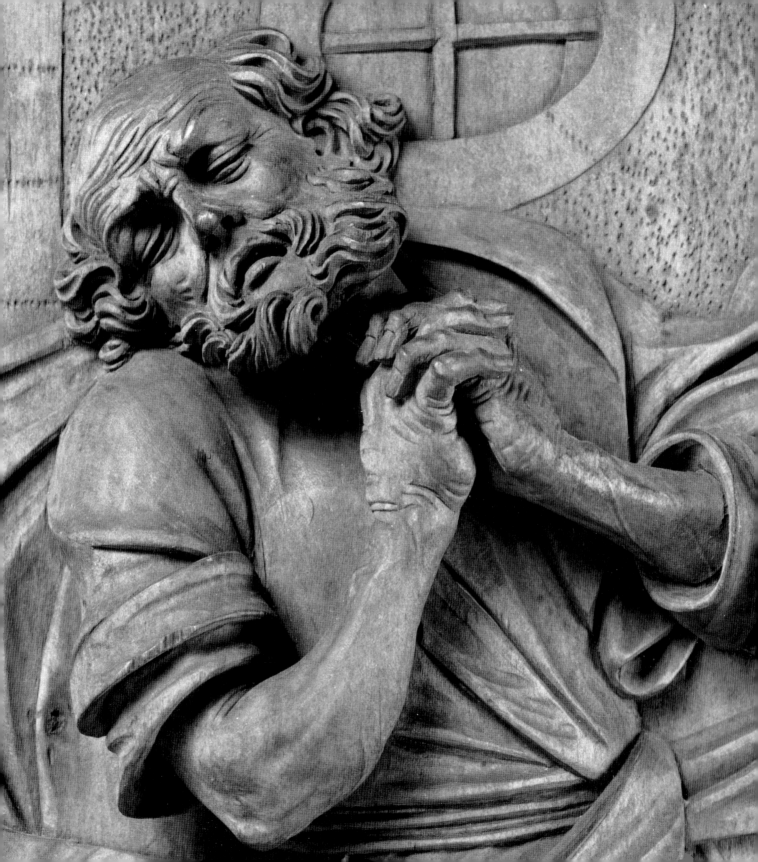

Summary Catalogue of

European Sculpture

in The J. Paul Getty Museum

Peter Fusco

THE J. PAUL GETTY MUSEUM ❧ LOS ANGELES

Christopher Hudson, Publisher
Mark Greenberg, Managing Editor
Shelly Kale, Copy Editor
Kurt Hauser, Designer
Amy Armstrong, Production Coordinator

© 1997 The J. Paul Getty Museum
1200 Getty Center Drive, Suite 1000
Los Angeles, California 90049-1687

Library of Congress Cataloging-in-Publication Data

J. Paul Getty Museum.
 Summary Catalogue of European Sculpture in the J. Paul
Getty Museum / Peter Fusco.
 p. cm.
 ISBN 0-89236-488-2
 1. Sculpture—California—Malibu—Catalogs. 2. J. Paul Getty Museum—
Catalogs. I. Fusco, Peter, 1945- . II. Title.
NB25.M36J25 1997
730′.74794′93—dc21 97-16753
 CIP

On the front and back covers:
Joseph Chinard
Bust of Madame Récamier
88.SC.42
see page 18

Frontispiece:
Christoph Daniel Schenck
The Penitent Saint Peter [detail]
96.SD.4.2
see page 47

On page 1:
Vincenzo Gemito
Medusa [detail]
86.SE.528
see page 25

On page 59:
Bust of Winter [detail]
82.SA.10
see page 62

On page 76:
Antonio Susini, or Giovanni Francesco Susini
Lion Attacking a Horse [detail]
94.SB.11.1
see page 48

Contents

Foreword

This catalogue appears just thirteen years after the Getty Museum began to collect European sculpture in a serious way. Almost every important piece in the book was bought during this period of rapid growth of the Museum's collections, growth made possible after 1982 by J. Paul Getty's enormous bequest. Four new collections—of sculpture, drawings, illuminated manuscripts, and photographs—have been formed alongside the collections of antiquities, decorative arts, and paintings originally begun by Getty, and in the process the Museum's holdings have been transformed almost beyond recognition.

Getty himself seems to have had no interest at all in buying sculpture after antiquity, despite his avid interest in the sculptors of ancient Greece and Rome and despite his love of French decorative arts and furniture. A few unimportant sculptures bought to adorn commodes, and Giambologna's marble figure of a female nude (perhaps Venus), bought in 1982, were all the Museum had to display before the appointment of Peter Fusco as Curator of Sculpture in 1984. We had calculated that despite the rarity of great masterpieces in private hands and the inflation of the art market, it would still be possible to form a fine collection of sculpture within a reasonable number of years. Now this has come to pass. After great effort on the part of the curator and his staff, some luck, and the skills of art dealers, there are more than 125 pieces forming a collection that has already attained a distinctive shape. It is strongest in Renaissance and Baroque works, especially bronzes, which are surpassed in this country only by those of the much older Metropolitan Museum of Art and Walters Art Gallery. There are also pieces in marble, terra-cotta, and bronze by many of the greatest sculptors of all eras. In many ways the collection still shows signs of youth, especially in its erratic chronological distribution. Medieval sculpture has proven to be practically unobtainable. At the other end of the timescale, pieces from the nineteenth century have been bought only very selectively, partly because there are important collections in other Los Angeles museums and partly because these works are disappearing into museums more slowly than older sculpture. Fortunately for us, there is a long time ahead.

A two-volume catalogue giving full scholarly treatment to each work of European sculpture is being prepared for publication within a few years' time. A handbook for laypersons called *Looking at European Sculpture: A Guide to Technical Terms*, copublished with the Victoria and Albert Museum, has recently appeared, and, in 1998, *Masterpieces of European Sculpture* will provide general readers with a well-illustrated survey of highlights. We want these books, as well as the handsome galleries of sculpture we are about to open in the new Getty Museum at the Getty Center in Los Angeles, to help the public better appreciate this sometimes neglected art form.

The Getty's collection owes its excellence to the remarkable taste, scholarly judgment, and tenacity that Peter Fusco has applied to its formation. His leadership is reflected in the devotion of the curatorial team that has helped him build the collection and produce this catalogue. I am glad to have this chance to salute him for all that he has accomplished.

~ John Walsh
Director

Acknowledgments

This summary catalogue is a distillation of the research, insights, and informed opinions of numerous people: the interns, guest scholars, and guest conservators who have spent time at the Museum during the last thirteen years, the numerous visiting colleagues from other museums and academic institutions, auction house personnel who initially catalogued many of the works, and the art dealers who initially discovered many of them. A fuller, more detailed recognition of the specific contributions made to our understanding of the J. Paul Getty Museum's collection of European sculpture will be provided in the planned two-volume catalogue of the collection. For now, I wish to recognize primarily the help provided by the staff of the Getty Center. I am indebted to the Museum Services Department of the Getty Conservation Institute—particularly its head, David Scott, and former employee Francesca Bewer, and to all the current and former members of the Museum's Department of Decorative Arts and Sculpture Conservation—particularly its head, Brian Considine, and Jane Bassett, Joe Godla, Gordon Hanlon, Abby Hykin, George Johnson, Billie Milam, Mark Mitton, Adrienne Pampe, Barbara Roberts, and Linda Strauss. It cannot be overstated how privileged a curator is to have access to the expertise of gifted conservation scientists, conservators, and mount-makers. I also wish to thank, for their extraordinary and ongoing help, the staff members of the Getty Research Institute; without them, none of the Museum's publications would be possible. For the outstanding photographs, I am indebted to the staff of the Museum's Department of Photo Services—particularly its head, Charles Passela, and Jack Ross, who is responsible for the majority of the photos in this book. I would also like to thank the staff members of the Museum's Preparations Department, headed by Bruce Metro; their careful handling of the collections, moving objects to the conservation laboratory for inspection and to the photography studio, has been essential. Similarly, the Museum's Registrar, Sally Hibbard, and her staff have provided invaluable help arranging the safe packing and shipping of these works to the Museum, and after arrival, the careful tracking of their movements.

The two most important contributors to this catalogue are my colleagues in the Department of European Sculpture and Works of Art, Associate Curators Peggy Fogelman and Catherine Hess, who have produced the lion's share of the acquisition proposals and other related research on the Museum's European sculpture; their brilliant work has provided the foundation for the information presented here; any errors or inaccuracies are mine. I am equally indebted to the Department's staff assistant, Dottie Goggin, who typed and retyped the innumerable drafts of this catalogue. For some last-minute checking of details and for preparing the subject index, I am grateful, respectively, to interns Victoria Avery and Simon Stock.

For the careful editing of the text I wish to thank Shelly Kale. Kurt Hauser was responsible for the elegant design and layout of the volume; Mark Greenberg and Amy Armstrong shepherded the book through its editing, design, and production. I am grateful to all of them.

For their collaboration in building the Museum's collection of European sculpture, and for their encouragement to publish it, I am grateful to Harold Williams, John Walsh, and Deborah Gribbon. No curator could ask for more enlightened, consummately professional, administrative support.

Finally, I wish to thank my wife, Laurie, whose taste and knowledge have informed, at every stage, the building of the collection which is published here, and whose love and support make possible everything that I do.

~ Peter Fusco

Note to the Reader

This summary catalogue presents the European sculpture in the J. Paul Getty Museum as of August 1997.

For this catalogue, the definition of *sculpture*, in determining which objects should be included and which excluded, is somewhat arbitrary. On the one hand, the catalogue is overly inclusive and illustrates all of the Museum's European ceramic and metalwork objects that are essentially comprised of figural elements and/or that bear some relationship to an artist who was primarily a sculptor. On the other hand, wood furniture, even if it contains carved, figural elements, is excluded; but a marble table by Franzoni, who was primarily a sculptor, is included. My colleagues in charge of the Department of Antiquities and the Department of Decorative Arts, respectively, Marion True and Gillian Wilson, have graciously allowed me to include, from their departmental collections, several works that I believe may be of interest to students of European sculpture. Such works include the large, red marble *Centaur*, which may be an eighteenth-century copy after a Roman antique, and several eighteenth-century procelain figural groups.

Each of the entries includes: a reproduction of the work; the artist's name; the artist's nationality followed in parentheses by the artist's primary city or cities of activity (no city is given for French artists primarily active in Paris/ Versailles or for English artists primarily active in London); the artist's birth and death dates or dates of activity; the work's title; the work's date of execution; medium; measurements; inscriptions; and accession number.

Entries are arranged alphabetically by artists' birth names, and artists with composite last names such as *van Opstal, della Robbia, van der Schardt*, and *de Vries* are listed in alphabetical order under *Opstal, Robbia, Schardt*, and *Vries.* If there is more than one listing under the same artist's name, the works are arranged chronologically by date of execution. Cross-references are provided when a work is the result of the collaboration of two or more artists. For works in which such qualifications as *after a model by, circle of, faker of,* or *workshop of* are used, the work is listed under the name of the artist being referred to by the qualification. Works by unknown artists are listed at the end and are arranged alphabetically, first by nationality, and within each national category, by what is assumed to be chronological order.

Measurements are in inches with metric conversions. For the most part, a single measurement has been given and this indicates height; two measurements indicate height by width; a third measurement is depth; the diameter for circular objects follows the abbreviation *diam.* For busts, the height of the work given is followed by the words *including the socle* when it is believed that the socle is original to the work it supports. For portraits, the birth and death dates (or reign dates) of the sitter, when known, are given in parentheses following the sitter's name.

Locations of inscriptions on reliefs are given from the spectator's point of view. For the location of inscriptions on three-dimensional objects, *right* and *left* should be understood as proper left and right; i.e., from the sculpture's perspective. The presence of illegible words and/or letters in inscriptions is indicated by a space between brackets: []. When illegible portions of the inscriptions can be identified by their context, the implied letters or numbers are placed between the brackets. A slash mark, "/", in an inscription, indicates that the subsequent part of the inscription is a new line of text, appearing on the object below the preceding line.

Many of the works presented here are previously unpublished except for their listing in the acquisitions supplements at the end of the annual volumes of the *J. Paul Getty Museum Journal.* Given their relative lack of

publication and the fact that the majority of these works were acquired only within the last thirteen years, there remains a great deal about them that is unknown, and it is hoped that this summary catalogue will encourage readers to bring new and/or more correct information about them to the attention of the J. Paul Getty Museum's Department of European Sculpture and Works of Art.

~ Peter Fusco

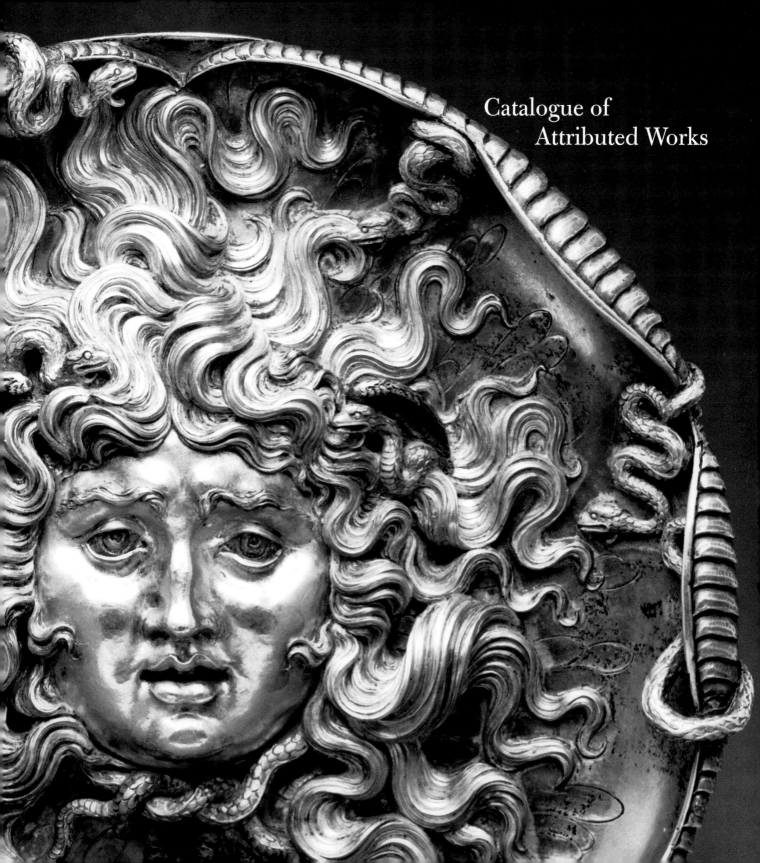

Catalogue of
Attributed Works

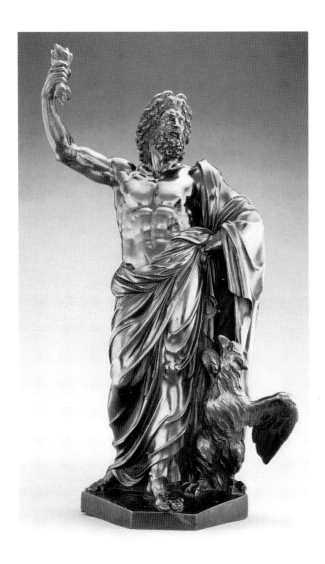

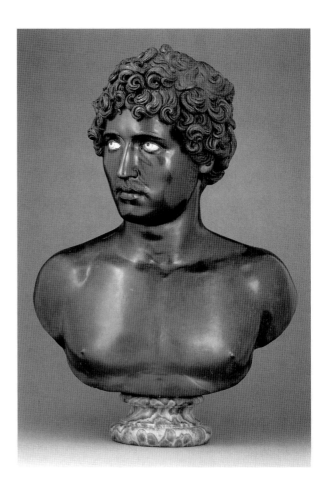

MICHEL ANGUIER
French, 1612–1686
Jupiter, probably cast toward the end of the
seventeenth century from a model of 1652
Bronze
61 cm (24 in.)
94.SB.21

PIER JACOPO ALARI-BONACOLSI, called ANTICO
Italian (Mantua), ca. 1460–1528
Bust of a Young Man, ca. 1520
Bronze with silver eyes
54.6 cm (21½ in.)
86.SB.688

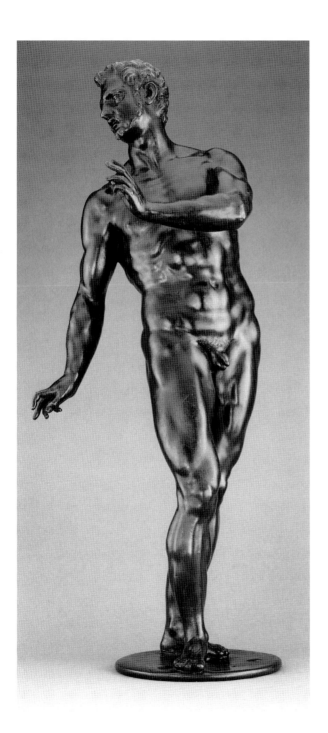

TIZIANO ASPETTI
Italian (active in Venice, Padua, Pisa, and Florence),
ca. 1559–1606
Male Nude, ca. 1600
Bronze
74.9 cm (29 ½ in.)
88.SB.115

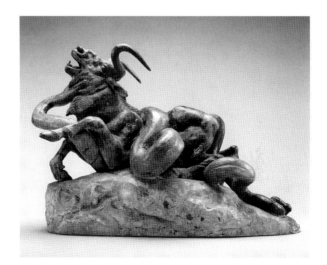

ANTOINE-LOUIS BARYE
French, 1796–1875
Python Killing a Gnu, 1834–35
Plaster retouched with red wax
27.9 cm (11 in.)
Signed on the base: *BARYE*
85.SE.48

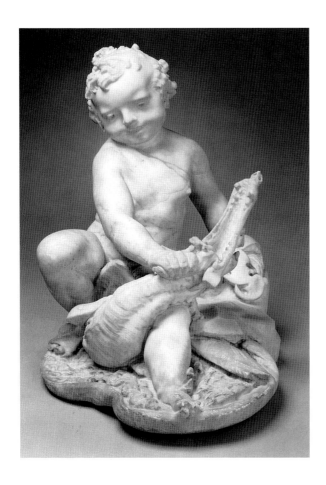

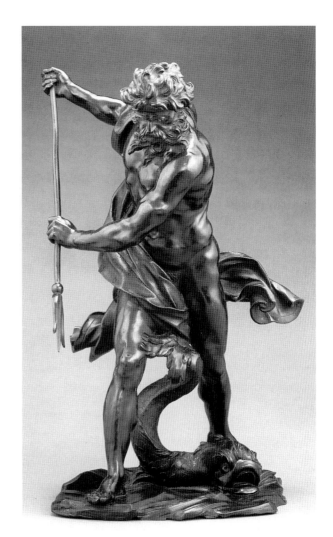

GIANLORENZO BERNINI
Italian (Rome), 1598–1680
Boy with a Dragon, ca. 1614–20
Marble
55.9 cm (22 in.)
87.SA.42

After GIANLORENZO BERNINI
Italian (Rome), 1598–1680
Neptune and Dolphin, seventeenth century
Bronze
55.9 cm (22 in.)
94.SB.45

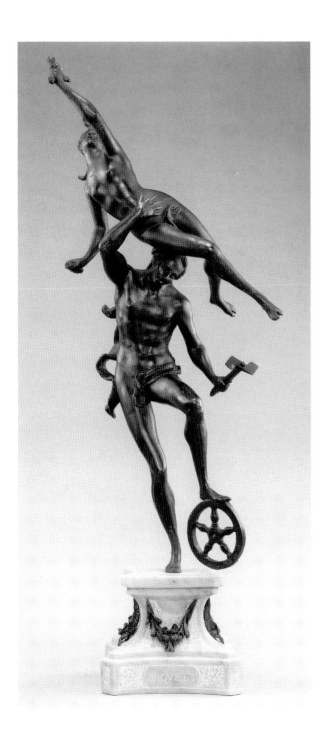

FRANCESCO BERTOS
Italian (active in Rome, Padua, and Venice),
active 1696–1739
Stupidity and Fortune, first half of the eighteenth century
Bronze on a marble base
63.2 cm (24 ⅞ in.), including base
Inscribed on top of the marble base: *OPVS BERTOS*;
around the sides of the base: *STVLTVS/VBIQVE ET/FORTVNA/
CONVENIVNT*
85.SB.73.1

FRANCESCO BERTOS
Italian (active in Rome, Padua, and Venice),
active 1696–1739
Industry and Virtue, first half of the eighteenth century
Bronze on a marble base
63.2 cm (24 ⅞ in.), including base
Inscribed on top of the marble base: *OPVS BERTOS*; on sides
of the base: *STVDIVM/FELICITERET/VIRTVS/ELVCENT*
85.SB.73.2

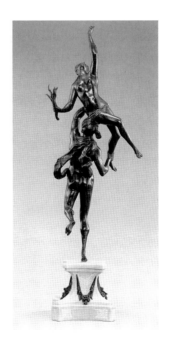

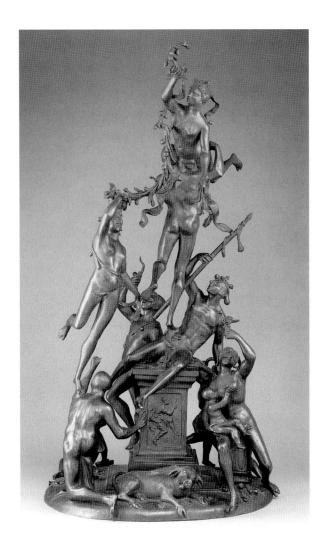

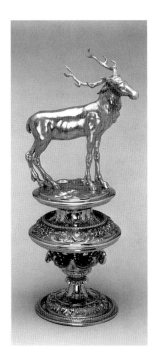
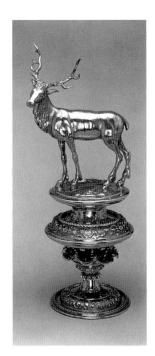

FRANCESCO BERTOS
Italian (active in Rome, Padua, and Venice),
active 1696–1739
Group of Eleven Figures (probably *An Allegory of
Autumn*), first half of the eighteenth century
Bronze
79.5 cm (31⅟₁₆ in.)
Inscribed: *BERTOS/INVENTOR/ET SCVLTOR/SOLVS/
DEI GRATIA/FVSIT/PERFECIT/FECIT*
85.SB.74

JOHAN LUDWIG BILLER THE ELDER
German (Augsburg), 1656–1732
Stag, ca. 1680–1700
Gilt silver
63.5 cm (25 in.)
Stamped on one antler and on the base: *ILB*; the Augsburg
silver mark is also stamped five times on the base
85.SE.442.1

JOHAN LUDWIG BILLER THE ELDER
German (Augsburg), 1656–1732
Stag, ca. 1680–1700
Gilt silver
66.5 cm (26³⁄₁₆ in.)
85.SE.442.2

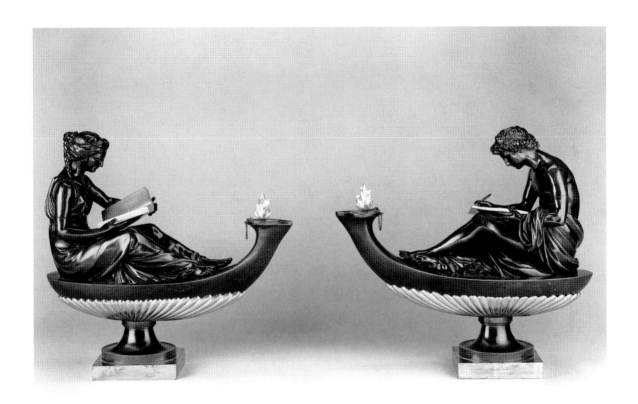

After a model by LOUIS-SIMON BOIZOT
French, 1743–1809
Cast by Pierre-Philippe Thomire
French, 1751–1843
Lamp with an Allegorical Figure of Study (L'Etude),
ca. 1780–85
Parcel-gilt bronze
33 cm (13 in.)
88.SB.113.1

After a model by LOUIS-SIMON BOIZOT
French, 1743–1809
Cast by Pierre-Philippe Thomire
French, 1751–1843
*Lamp with an Allegorical Figure of Philosophy
(La Philosophie),* ca. 1780–85
Parcel-gilt bronze
33 cm (13 in.)
88.SB.113.2

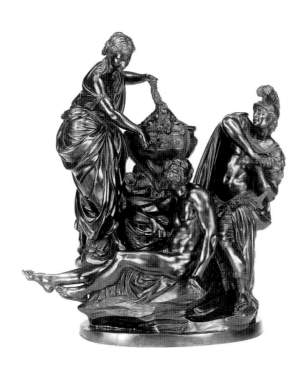

After a model attributed to LOUIS-SIMON BOIZOT
French, 1743–1809
Medea Rejuvenating Aeson, model ca. 1785–90,
probably cast later
Bronze
67 cm (26⅜ in.)
74.SB.6

EDME BOUCHARDON
French, 1698–1762
Saint Bartholomew, ca. 1734–50
Terra-cotta
57.2 cm (22½ in.)
94.SC.23

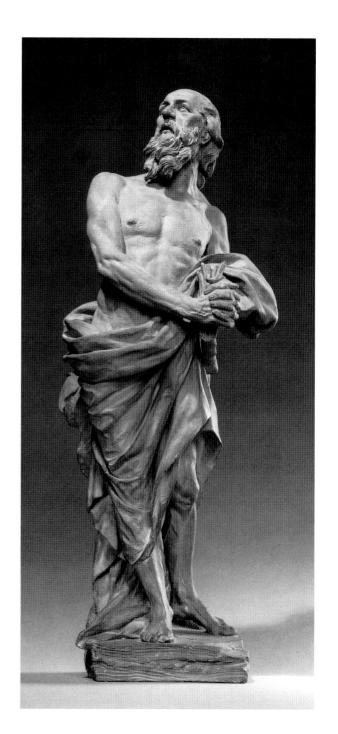

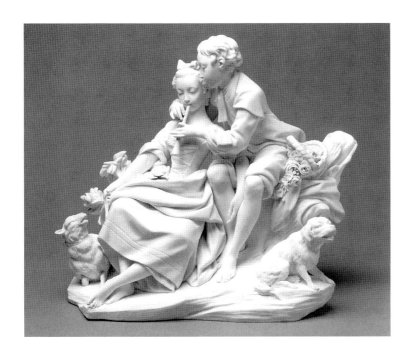

After designs by FRANÇOIS BOUCHER
French, 1703–1770
Sèvres manufactory
The Flute Lesson (Le Fluteur), ca. 1757–66
Soft-paste biscuit porcelain with traces of
red pigment
22.2 cm (8¾ in.)
Incised on the back: *F*
70.DE.98.1

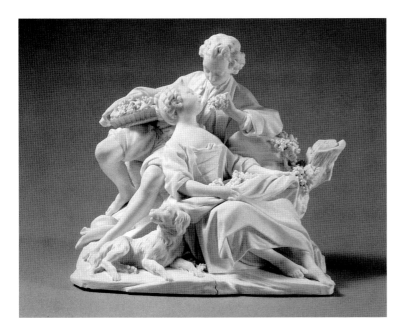

After designs by FRANÇOIS BOUCHER
French, 1703–1770
Sèvres manufactory
The Grape Eaters (Les Mangeurs de Raisins),
ca. 1757–66
Soft-paste biscuit porcelain with traces of red
pigment
22.9 cm (9 in.)
70.DE.98.2

GASPERO BRUSCHI (see FOGGINI)

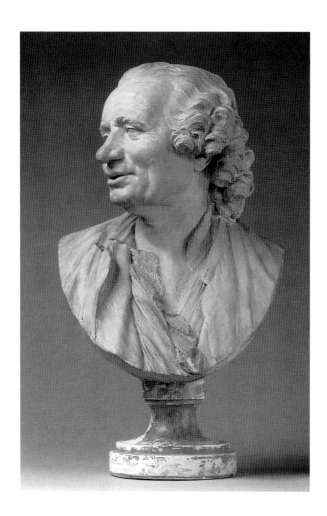

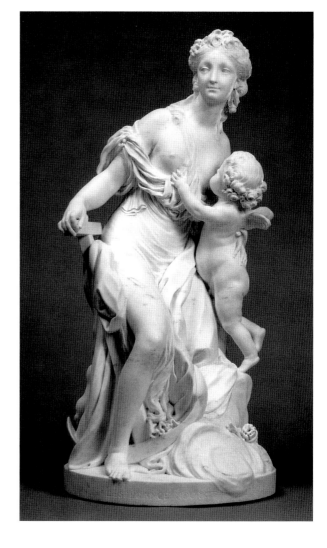

JEAN-JACQUES CAFFIERI
French, 1725–1792
Bust of Alexis-Jean-Eustache Taitbout (1705–1778), 1762
Terra-cotta on a plaster socle
64.5 cm (25⅜ in.), including socle
Inscribed on the back: *M. Taitbout, ecuyer, chevalier de
St. Lazare consul de France a Naples, Fait par j j Caffieri
en 1762*
96.SC.344

JEAN-JACQUES CAFFIERI
French, 1725–1792
Hope Nourishing Love, 1769
Marble
72.1 cm (28⅜ in.)
Inscribed on the front of the base: *L'ESPÉRANCE
NOURRIT L'AMOUR*; on the back of the base:
j.j. CAFFIERI INVENIT & SCULPSIT.1769.
86.SA.703

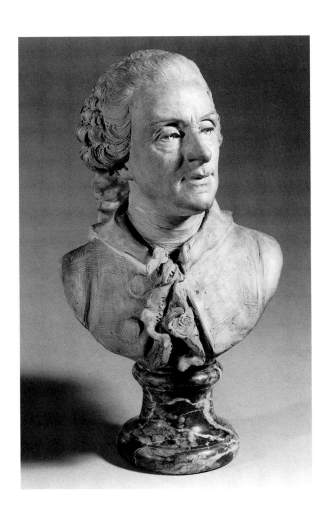

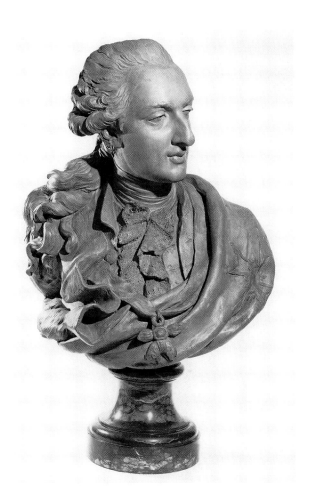

Attributed to JEAN-JACQUES CAFFIERI
French, 1725–1792
Bust of a Man (possibly *François Boucher*, 1703–1770),
ca. 1760
Terra-cotta on a marble socle
52.7 cm (20¾ in.), including socle
82.SC.11

Faker of JEAN-JACQUES CAFFIERI
French, 1725–1792
Bust of the Prince de Condé (1736–1818),
nineteenth century
Terra-cotta
77.8 cm (30⅝ in.), including socle
71.SC.435

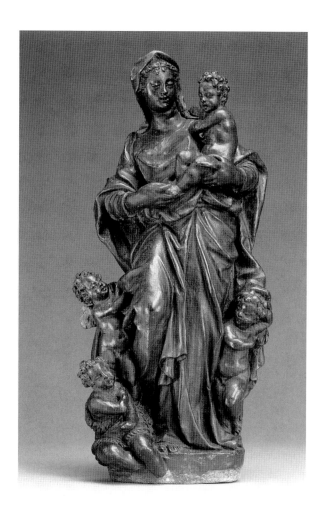

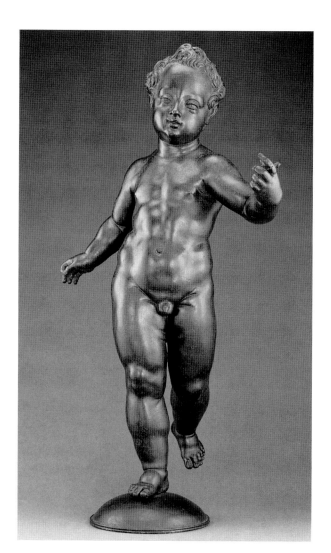

GIROLAMO CAMPAGNA
Italian (active in Venice and Padua), 1549/50 – 1625
*Madonna and Child with Angels and the Infant
Saint John the Baptist*, ca. 1585
Terra-cotta
44 cm (17⁵⁄₁₆ in.)
85.SC.59

GIROLAMO CAMPAGNA
Italian (active in Venice and Padua), 1549/50 – 1625
Infant (probably *The Christ Child*), ca. 1605 – 7
Bronze
83.2 cm (32¾ in.), excluding base
86.SB.734

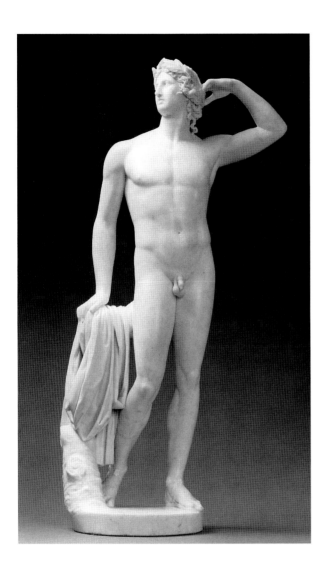

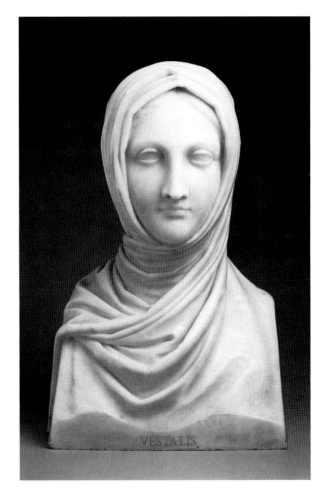

Antonio Canova
Italian (Rome), 1757–1822
Apollo Crowning Himself, 1781–82
Marble
84.8 cm (33 ⅜ in.)
Inscribed on the tree trunk:
ANT. CANOVA/VENET. FACIEB./1781
95.SA.71

Antonio Canova
Italian (Rome), 1757–1822
Herm of a Vestal Virgin, 1821–22
Marble
49.8 cm (19 ⅝ in.)
Inscribed on the front: *VESTALIS*
85.SA.353

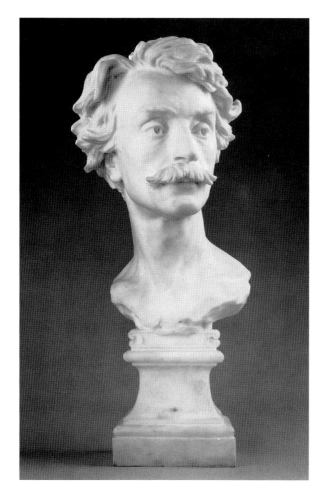

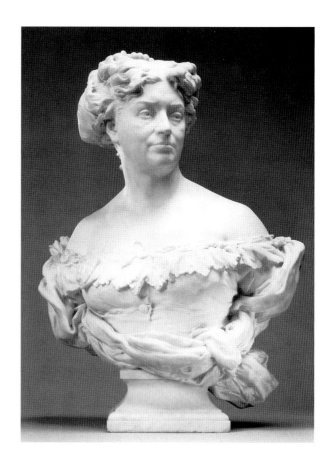

JEAN-BAPTISTE CARPEAUX
French, 1827–1875
Bust of Jean-Léon Gérôme (1824–1904), 1872–73
Marble
61 cm (24 in.), including socle
Signed on proper left side below the truncation:
Jb^te Carpeaux
88.SA.8

JEAN-BAPTISTE CARPEAUX
French, 1827–1875
Bust of Madame Alexandre Dumas fils
(1827–1875), 1873–75
Marble
80 cm (31½ in.), including socle
85.SA.47

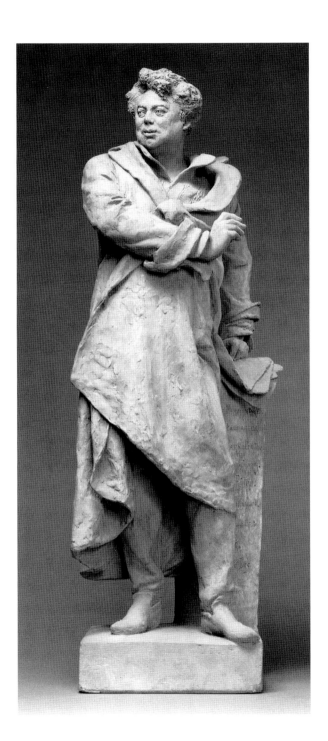

ALBERT-ERNEST CARRIER-BELLEUSE
French, 1824–1887
Model for a Monument to Alexandre Dumas père (1802–1870),
ca. 1883
Terra-cotta
80.7 cm (31¾ in.)
Signed on base: *A CARRIER BELLEUSE*; on square pillar:
*TROiS MOUSQUETAiES./ VINGT Ans APRÈS./LES QUARANtE
CinQ./ ComtESSE de CHARNY./ AngE PiTOU/ LA Reine
MARGOT./ Comte de MontE Cristo./ AcTÉ./ Etc. Etc. Etc.*
94.SC.19

BARTOLOMEO CAVACEPPI
Italian (Rome), 1716/17–1799
Bust of Emperor Caracalla (reigned A.D. 211–217), ca. 1750–70
Marble
71.1 cm (28 in.), including socle
Signed on the front: *BARTOLOMEVS /CAVACEPPI/ FECIT.*
94.SA.46

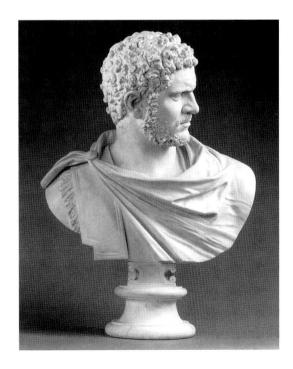

GIOVANNI DA CAVINO
Italian (Padua), 1500–1570
*Medallion with Laureate Bust of the Emperor
Vitellius* (reigned A.D. 69) [obverse] and
Mars Walking [reverse], sixteenth century
Bronze
Diam: 3.7 cm (1⁷⁄₁₆ in.)
Inscribed on the obverse: *AΣVITELLIVSΣ
GERMANICVS IMPΣAVGΣPMΣTRP*; on the
reverse: *S C*
75.NJ.90

BENVENUTO CELLINI?
Italian (Florence, also active at Fontainebleau),
1500–1571
Hercules Pendant, ca. 1540
Gold, enamel (white, blue, and black), and a
baroque pearl
6 x 5.4 cm (2⅜ × 2⅛ in.)
85.SE.237

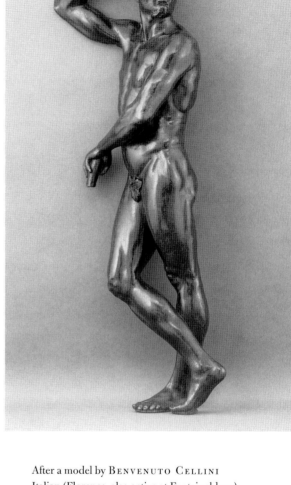

After a model by BENVENUTO CELLINI
Italian (Florence, also active at Fontainebleau),
1500–1571
Satyr, cast after a model of ca. 1542
Bronze
56.8 cm (22⅜ in.)
85.SB.69

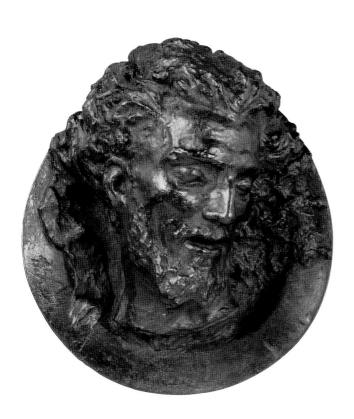

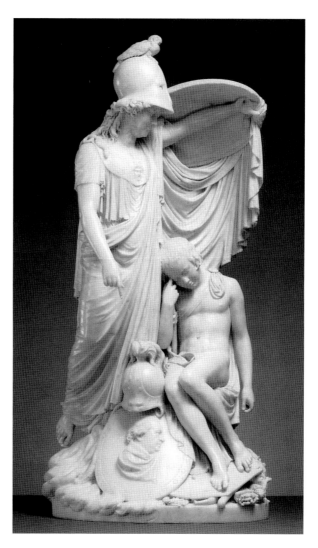

JEAN-BAPTISTE (called JOANNY) CHATIGNY
French (Lyon), 1834–1886
Head of Saint John the Baptist, 1869
Bronze
43.2 x 12.7 cm (17 × 5 in.)
Inscribed at the lower left: *J. Chatigny/1869 Lyon*
94.SB.78

JOSEPH CHINARD
French (Lyon), 1756–1813
Allegorical Portrait of the van Risamburgh Family, 1790
Marble
112.4 cm (44 ¼ in.)
Inscribed in the clouds on the base: *Chinard 1790*
94.SA.2

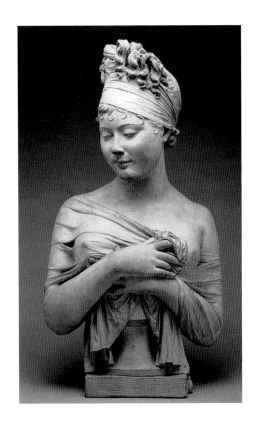

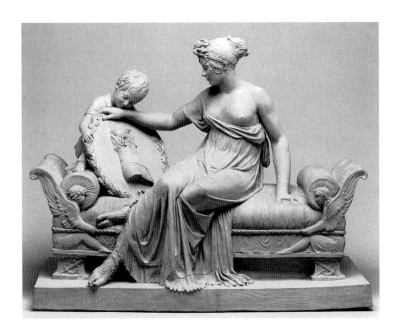

Joseph Chinard
French (Lyon), 1756–1813
Bust of Madame Récamier
(1777–1849), ca. 1801–2
Terra-cotta
63.2 cm (24 ⅞ in.), including socle
88.SC.42

Joseph Chinard
French (Lyon), 1756–1813
The Family of General Philippe-Guillaume Duhesme
(1766–1815), ca. 1808
Terra-cotta
56 × 34.9 × 70 cm (22 ¹/₁₆ × 13 ³/₁₄ × 27 ⁹/₁₆ in.)
Inscribed on the front of the daybed: *chinard statuaire a Lyon*
85.SC.82

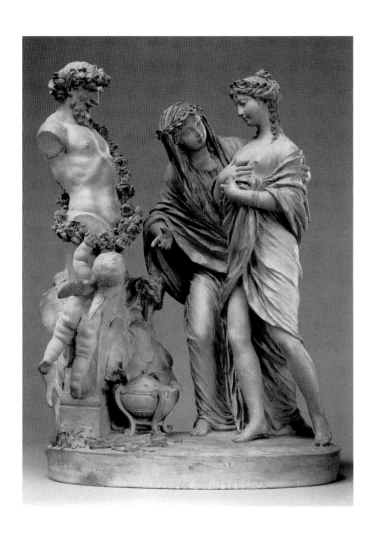

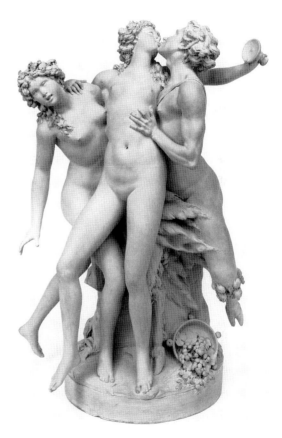

Claude Michel, called Clodion
French (born in Nancy, also active in Rome and Paris),
1738–1814
Vestal Presenting a Young Woman at the Altar of Pan, ca. 1775
Terra-cotta
45.1 cm (17¾ in.)
Signed on the clouds in the back at right: *CLODION*
(the N is reversed)
85.SC.166

Faker of Claude Michel, called Clodion
French (born in Nancy, also active in Paris
and Rome), 1738–1814
Satyr with Two Bacchantes, late nineteenth century
Terra-cotta
57.2 cm (22½ in.)
Inscribed: *CLODION 1784*
73.SC.40

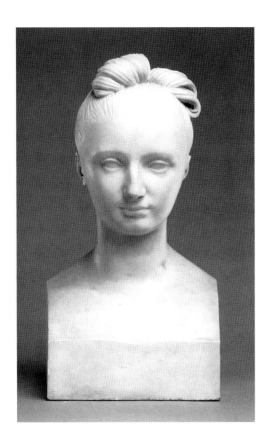

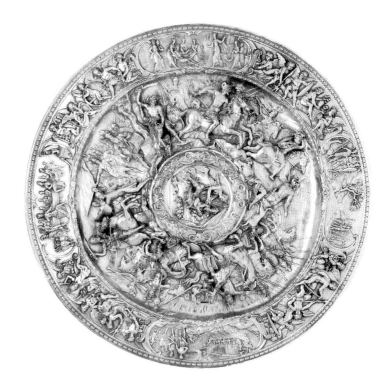

PIERRE-JEAN DAVID D'ANGERS
French (active in Angers and Paris), 1788–1856
Bust of Miss Mary Robinson, 1824
Marble
46.4 cm (18 ¼ in.)
Inscribed on the side of the base: *P. J. DAVID/1824*
93.SA.56

HENRI-FRANÇOIS DUBUISSON (see THOMIRE)

Perhaps modeled by FRANCESCO FANELLI
Italian (active in Genoa, England, and France),
ca. 1590–after 1653
After a sketch by Bernardo Strozzi
Italian (Genoa), 1581–1644
Probably executed by a Dutch or Flemish silversmith
Basin with Scenes from the Life of Cleopatra,
ca. 1620–25
Silver
Diam: 75.6 cm (29 ¾ in.)
85.DG.81

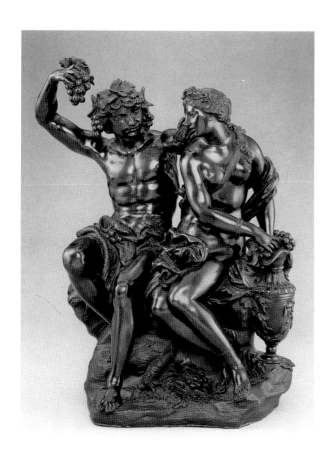

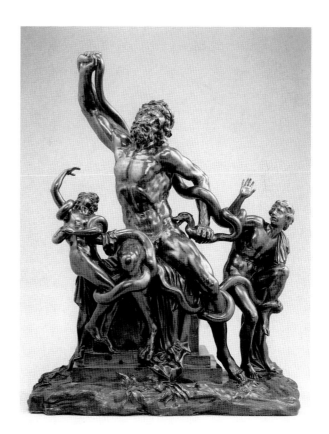

GIOVANNI BATTISTA FOGGINI
Italian (Florence), 1652–1725
Bacchus and Ariadne, ca. 1690
Bronze
40 cm (15 ¾ in.)
83.SB.333

Attributed to GIOVANNI BATTISTA FOGGINI
Italian (Florence), 1652–1725
Laocoön (after the antique), ca. 1720
Bronze
56 cm (22 ¹⁄₁₆ in.)
85.SB.413

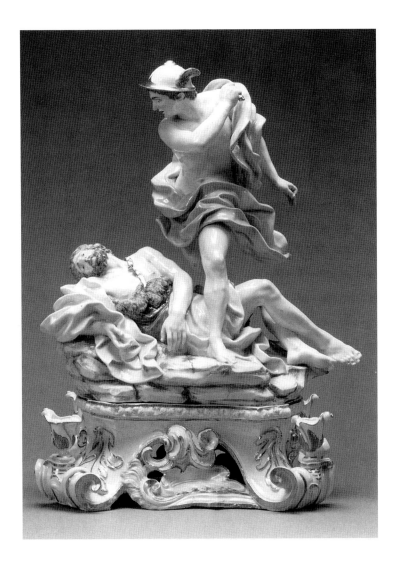

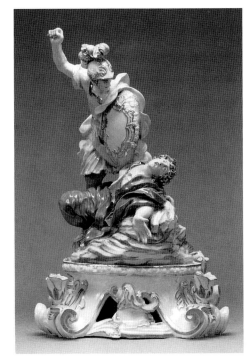

After a model by GIOVANNI BATTISTA FOGGINI
Italian (Florence), 1652–1725
Probably made by Gaspero Bruschi
Italian (Florence), 1701–1780, Doccia
Porcelain Factory
Perseus and Medusa, ca. 1749, after a model of
1713 or earlier
Porcelain, polychrome, and parcel-gilt
45.1 cm (17¾ in.)
Underside marked: *ll*
94.SE.76.2

After a model by GIOVANNI BATTISTA FOGGINI
Italian (Florence), 1652–1725
Probably made by Gaspero Bruschi
Italian (Florence), 1701–1780, Doccia Porcelain Factory
Mercury and Argus, ca. 1749
Porcelain, polychrome, and parcel-gilt
45.1 cm (17¾ in.)
Underside marked: *l*
94.SE.76.1

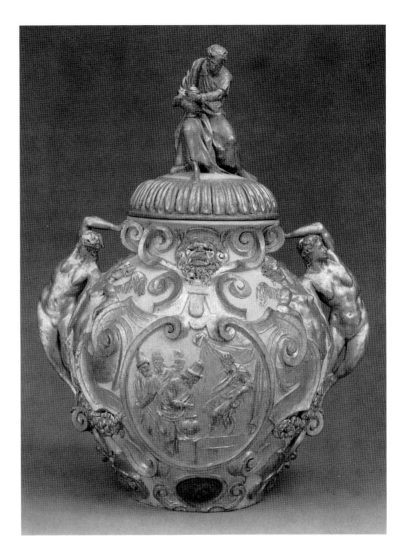

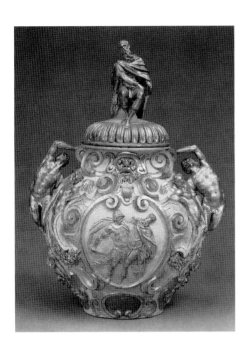

Attributed to ANNIBALE FONTANA
Italian (Milan), ca. 1540–1587
Drug Jar with Scenes from the Life of
Mithradates VI, King of Pontus (reigned
120–63 B.C.), ca. 1580
Terra-cotta with white paint and gilt
exterior and glazed interior
60 cm (23⅝ in.)
90.SC.42.1

Attributed to ANNIBALE FONTANA
Italian (Milan), ca. 1540–1587
Drug Jar with Scenes from the Life of Andromachus, Court
Physician to the Emperor Nero (reigned A.D. 54–68), ca. 1580
Terra-cotta with white paint and gilt exterior and glazed interior
60 cm (23⅝ in.)
90.SC.42.2

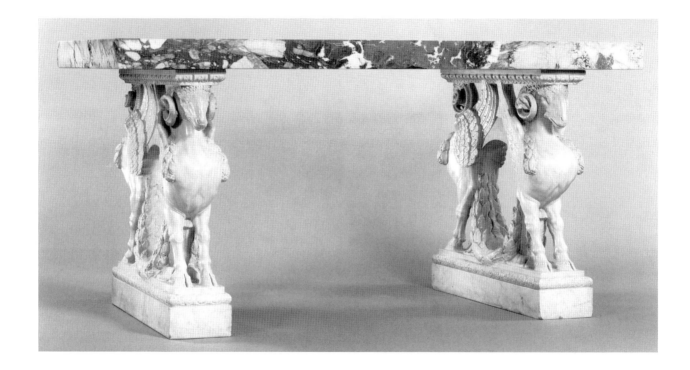

Francesco Antonio Franzoni
Italian (Rome), 1734–1818
*Table with Supports in the Form of
Winged Rams*, ca. 1780
Marble
100.3 cm (39 ½ in.), including top
93.DA.18

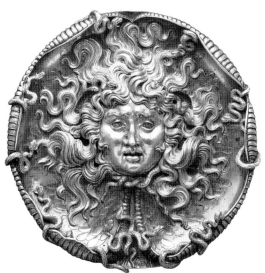

Francesco Antonio Franzoni
Italian (Rome), 1734–1818
Sketch for a Fireplace Overmantel, ca. 1789
Terra-cotta
53.5 × 42.6 cm (21¹⁄₁₆ × 16¾ in.)
95.SC.77

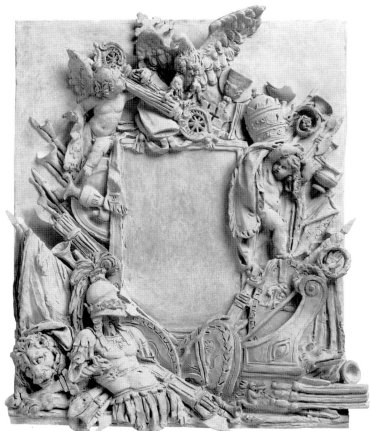

Vincenzo Gemito
Italian (Naples), 1852–1929
Medusa, 1911
Parcel-gilt silver
Diam: 23.5 cm (9 ¼ in.)
Signed and dated at the bottom center of
the obverse: *1911, GEMITO*
86.SE.528

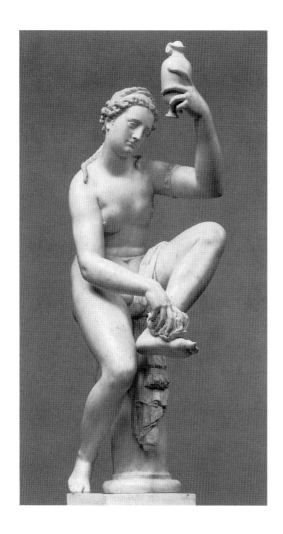

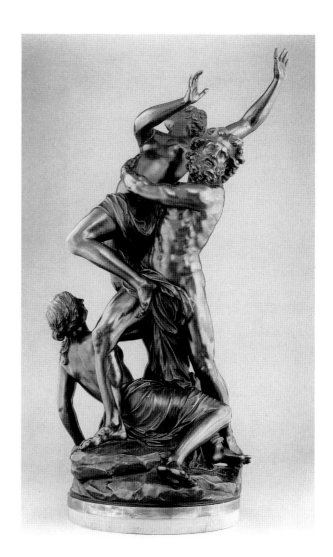

JEAN BOULOGNE (GIOVANNI BOLOGNA),
called GIAMBOLOGNA
Italo-Flemish (born in Douai, active mainly in
Florence), 1529–1608
Female Figure (possibly *Venus*, formerly titled
Bathsheba), 1571–73
Marble
114.9 cm (45 ¼ in.)
82.SA.37

GIAMBOLOGNA (see SUSINI)

FRANÇOIS GIRARDON
French, 1628–1715
Pluto Abducting Proserpine, cast ca. 1693–1710
Bronze
105.1 cm (41⅜ in.)
Signed on the top of the base: *F. Girardon Inv. et F.*
88.SB.73

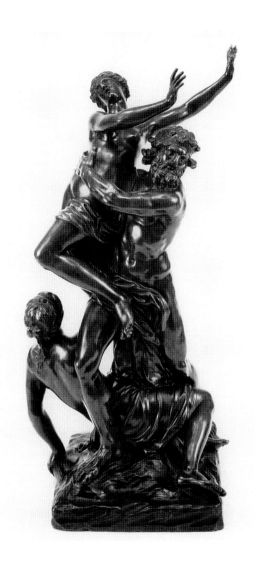

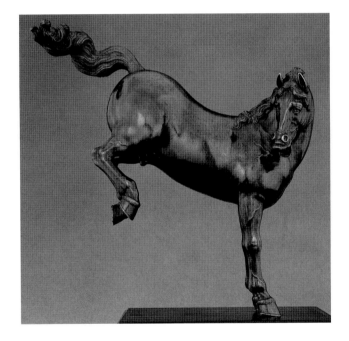

After a model by FRANÇOIS GIRARDON
French, 1628–1715
Pluto Abducting Proserpine, probably cast in the
late eighteenth century
Bronze
56.5 cm (22¼ in.)
74.SB.17

CASPAR GRAS
German (Innsbruck), ca. 1584/85–1674
Kicking Horse, ca. 1630
Bronze
34.3 cm (13½ in.)
85.SB.72

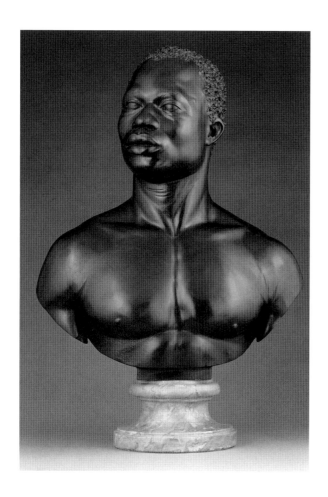

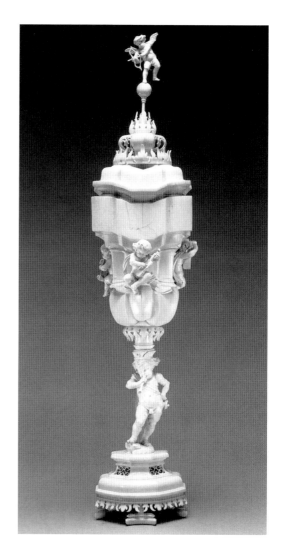

FRANCIS HARWOOD
English (active mainly in Florence), active 1748–1783
Bust of a Man, 1758
Black stone (*pietra da paragone*) on a yellow Siena
marble socle
69.9 cm (27 ½ in.), including socle
Inscribed on the lower proper left side and back:
F. Harwood Fecit 1758
88.SA.114

MARCUS HEIDEN
German (Coburg), active by 1618 until at least 1664
Covered Standing Cup, 1631 (the figural elements
probably added later in the seventeenth century)
Lathe-turned and carved ivory
63.5 cm (25 in.)
Inscribed under the base:
MARCUS.HEIDEN.COBURGENSIS.FECIT.1631
91.DH.75.1–.2

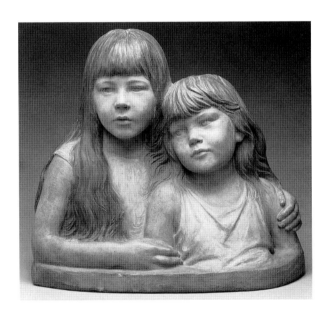

ADOLF VON HILDEBRAND
German (born in Marburg, active in Munich and Florence),
1847–1921
Double Portrait of the Artist's Daughters, 1889
Polychromed terra-cotta
50 cm (19 ¹¹⁄₁₆ in.)
86.SC.729

JEAN-ANTOINE HOUDON
French, 1741–1828
Bust of Louise Brongniart, ca. 1777
Marble
46 cm (18 ⅛ in.), including socle
Signed on the back: *houdon f.*
85.SA.220

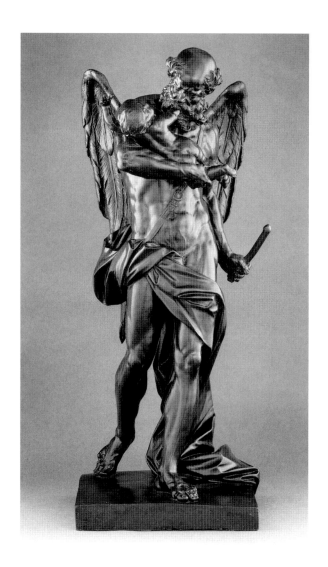

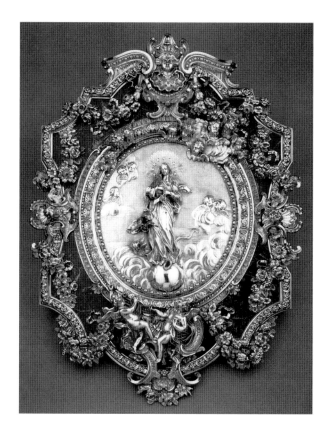

SIMON HURTRELLE
French, 1648–1724
Saturn Devouring One of His Children, ca. 1700
Bronze
65.4 cm (25 ¾ in.)
85.SB.126

FRANCESCO NATALE JUVARA
Italian (born in Messina, also active in Sicily and Rome),
1673–1759
*Wall Plaque with a Relief Representing the Virgin of
the Immaculate Conception*, 1730–40
Silver, gilt bronze, and lapis lazuli
69.7 × 52.1 cm (27 ⁷⁄₁₆ × 20 ½ in.)
85.SE.127

GENNARO LAUDATO (see SAMMARTINO)

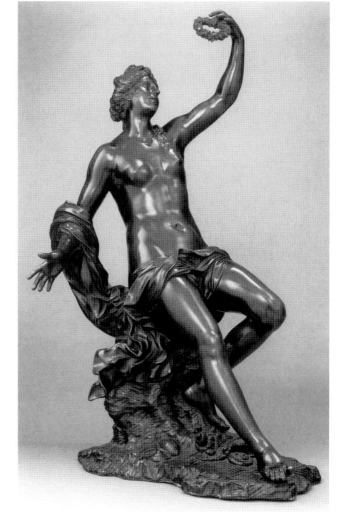

Francesco Laurana
Dalmatian (active in Naples, Sicily, and Provence),
1420–1502
Saint Cyricus, ca. 1470–80
Marble
49.5 cm (19 ½ in.)
96.SA.6

Attributed to Robert Le Lorrain
French (active in Paris and Strasbourg), 1666–1743
Venus Marina, ca. 1710
Bronze
64.8 cm (25 ½ in.)
74.SB.16

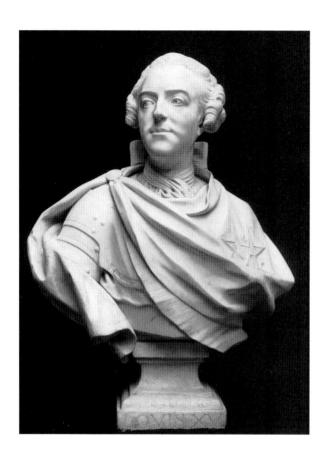

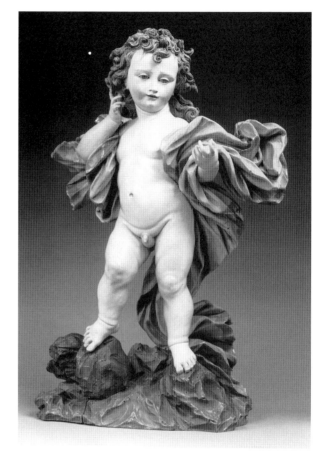

Faker of JEAN-BAPTISTE LEMOYNE
French, 1704–1778
Bust of Louis XV (reigned 1715–74), nineteenth century
Marble
85.1 cm (33 ½ in.), including socle
Inscribed across the shoulder at the back: *Roi de France et de Navarre*; on the back of the plinth: *par J.B. Lemoyne 1772 - de 69 ans.*
71.SA.446

Attributed to ANTON MARIA MARAGLIANO
Italian (Genoa), 1664–1739
Christ Child, ca. 1700
Polychromed wood with glass eyes
73.7 cm (29 in.)
96.SD.18

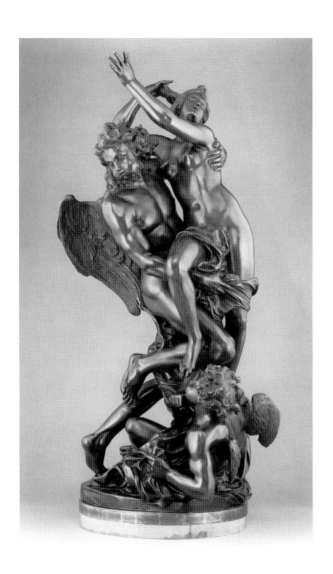

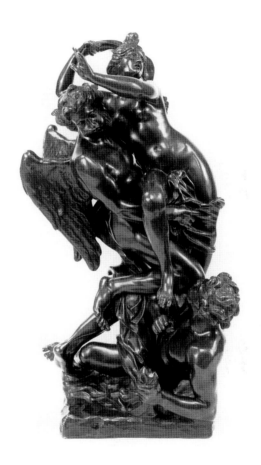

After a model by GASPARD MARSY
French, 1624–1681
Boreas Abducting Orithyia, cast ca. 1693–1710
Bronze
105.1 cm (41⅜ in.)
88.SB.74

After a model by GASPARD MARSY
French, 1624–1681
Boreas Abducting Orithyia, probably cast in the late
eighteenth century
Bronze
55.3 cm (21¾ in.)
74.SB.18

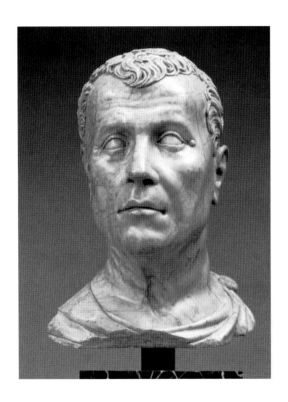

Conrat Meit
German (active in France, Brabant, Mechelen, and Antwerp), ca. 1480s–1550/51
Head of a Man (possibly *Cicero*, 106–43 B.C.), ca. 1520
Alabaster
33 cm (13 in.)
96.SA.2

George Minne
Belgian (active in Ghent, Brussels, and Sint-Martins-Laten), 1866–1941
Adolescent I, ca. 1891
Marble
42.9 cm (16⅞ in.)
Artist's monogram in a raised circle on top of the base: *M*
97.SA.6

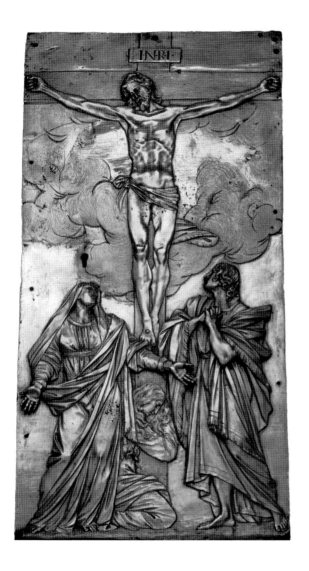

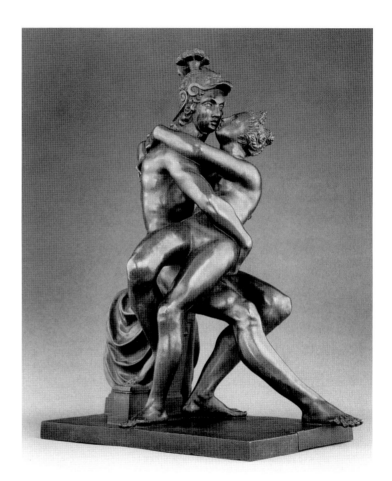

FRANCESCO MOCHI
Italian (active in Rome and Parma), 1580–1654
Tabernacle Door with the Crucifixion, ca. 1635–40
Gilt bronze
55.3 × 28.9 cm (21¾ × 11⅜ in.)
Signed on the reverse, in black ink, in a later hand:
Francesc[us] Mochi
95.SB.2

Attributed to HANS MONT
Flemish (active in Prague), 1571–1584
Mars and Venus, ca. 1575
Bronze
53.3 cm (21 in.)
85.SB.75

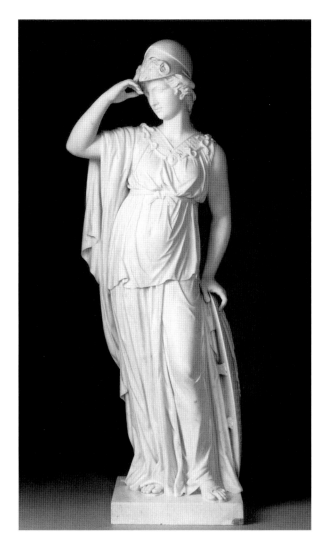

JOSEPH NOLLEKENS
English, 1737–1823
Venus, 1773
Marble
124 cm (48 $^{13}/_{16}$ in.)
Signed and dated on the side of the base: *Nollekens F. 1773*
87.SA.106

JOSEPH NOLLEKENS
English, 1737–1823
Minerva, 1775
Marble
144 cm (56 $^{11}/_{16}$ in.)
Signed and dated on the side of the base: *Nollekens F : 1775*
87.SA.107

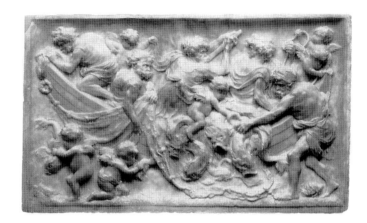

GERARD VAN OPSTAL
Flemish (active in Flanders and Paris), ca. 1605–1668
Marine Scene, ca. 1640
Alabaster
61.9 × 101.8 × 7.3 cm (24 ⅜ × 40 1/16 × 2 ⅞ in.)
85.SA.167.1

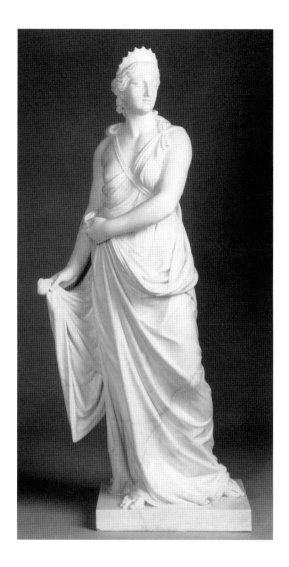

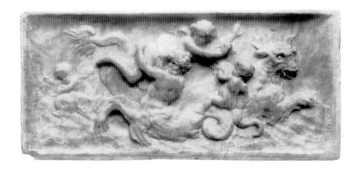

JOSEPH NOLLEKENS
English, 1737–1823
Juno, 1776
Marble
139.1 cm (54 ¾ in.)
Signed and dated on the side of the base:
Nollekens F+ 1776
87.SA.108

GERARD VAN OPSTAL
Flemish (active in Flanders and Paris), ca. 1605–1668
Marine Scene, ca. 1640
Alabaster
40 × 85.1 × 7 cm (15 ¾ × 33 ½ × 2 ¾ in.)
85.SA.167.2

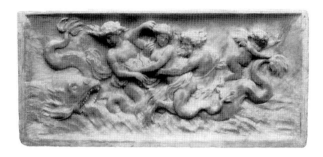

GERARD VAN OPSTAL
Flemish (active in Flanders and Paris), ca. 1605–1668
Marine Scene, ca. 1640
Alabaster
40 × 84.8 × 7.6 cm (15¾ × 33⅜ × 3 in.)
85.SA.167.3

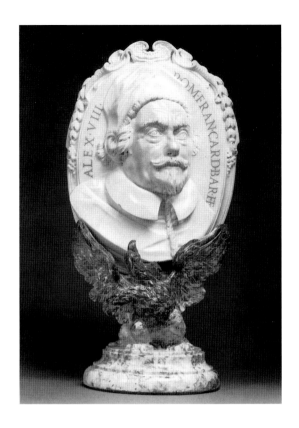

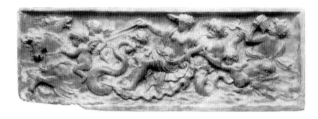

GERARD VAN OPSTAL
Flemish (active in Flanders and Paris), ca. 1605–1668
Marine Scene, ca. 1640
Alabaster
39.7 × 111.1 × 7.3 cm (15⅝ × 43¾ × 2⅞ in.)
85.SA.167.4

LORENZO OTTONI
Italian (Rome), 1648–1726
Portrait Medallion of Pope Alexander VIII
(Pietro Vito Ottoboni, born 1610; reigned
1689–1691), 1699–1700
White marble medallion on a *bigio antico* marble socle
88.9 cm (35 in.), including socle
95.SA.9.1–.2

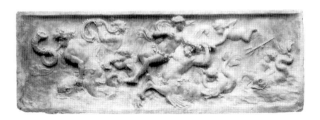

GERARD VAN OPSTAL
Flemish (active in Flanders and Paris), ca. 1605–1668
Marine Scene, ca. 1640
Alabaster
39.7 × 111.1 × 7 cm (15⅝ × 43¾ × 2¾ in.)
85.SA.167.5

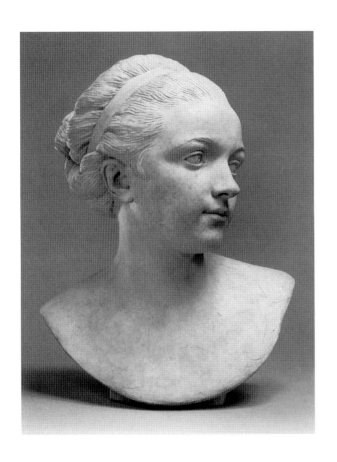

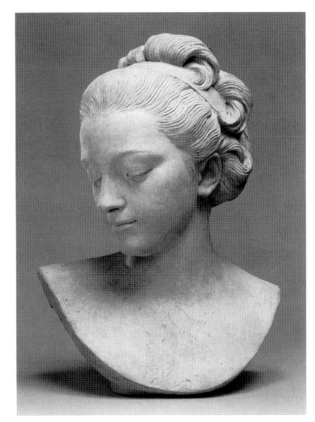

Augustin Pajou
French, 1730–1809
Ideal Female Head, 1769–70
Terra-cotta
44.5 cm (17 ½ in.)
Inscribed on the back: *Pajou/ faciebat*
87.SC.114.1

Augustin Pajou
French, 1730–1809
Ideal Female Head, 1769–70
Terra-cotta
43.8 cm (17 ¼ in.)
Inscribed on the back: *Pajou/ faciebat*
87.SC.114.2

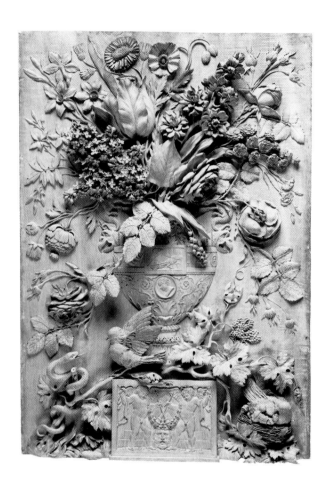

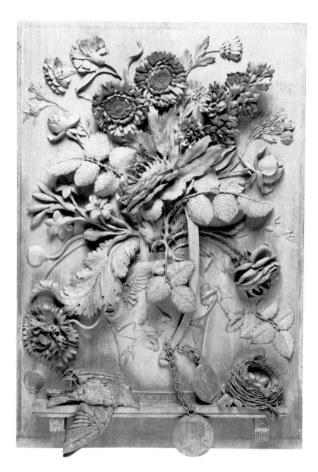

AUBERT-HENRI-JOSEPH PARENT
French (born in Cambrai, died in Valenciennes),
1753–1835
Still Life with Flowers, 1789
Limewood
68.9 × 47.9 cm (27 ⅛ × 18 ⅞ in.)
Inscribed under the base: *AUBERT PARENT FECIT AN. 1789*
84.SD.76

AUBERT-HENRI-JOSEPH PARENT
French (born in Cambrai, died in Valenciennes),
1753–1835
Still Life with Flowers, 1791
Limewood
58.7 × 39.7 cm (23 ⅛ × 15 ⅝ in.)
Inscribed under the base: *AUBERT PARENT. 1791*
84.SD.194

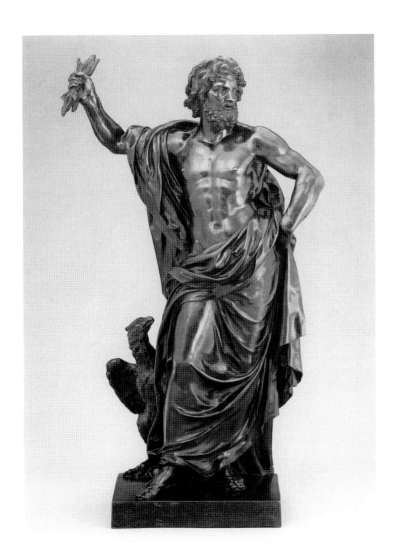

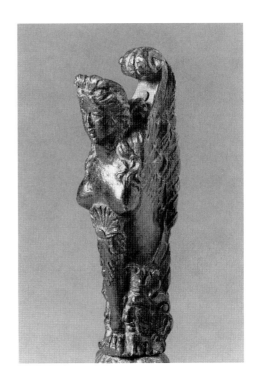

After a model by ANDREA BRIOSCO,
called RICCIO
Italian (Padua), 1470–1532
Sphinx, sixteenth century
Bronze
8.9 cm (3 ½ in.)
85.SB.62

After a model attributed to JEAN RAON
French, 1630–1707
Jupiter, model ca. 1670, probably cast ca. 1680–1700
Bronze
74.3 cm (29 ¼ in.)
92.SB.106

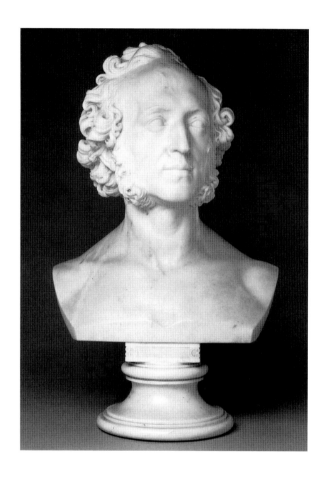

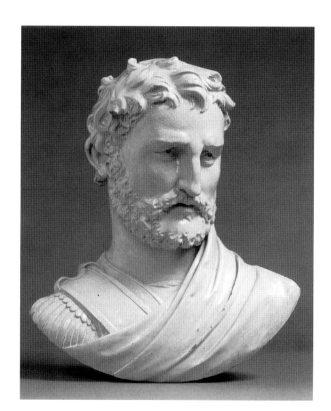

Ernst Friedrich August Rietschel
German, 1804–1861
Bust of Felix Mendelssohn (1809–1847), 1848
Marble
59.7 cm (23 ½ in.)
Inscribed on the back: *E. Rietschel 1848*
86.SA.543

Girolamo della Robbia
Italian (Florence, active in France), 1488–1566
Bust of a Man, 1526–35
Tin-glazed earthenware
46.4 cm (18 ¼ in.)
95.SC.21

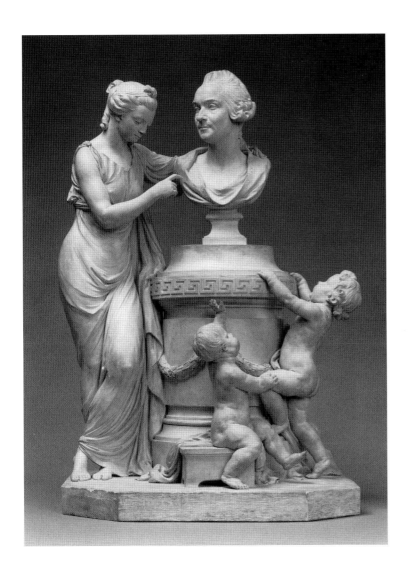

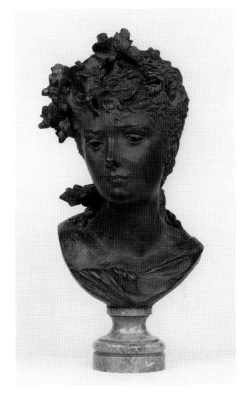

Attributed to PHILIPPE-LAURENT ROLAND
French, 1746–1816
Allegorical Group with a Portrait Bust of an Architect
(possibly *Pierre Rousseau*, 1751–1810 or 1829), ca. 1780–90
Terra-cotta
67.3 cm (26 ½ in.)
97.SC.9

AUGUSTE RODIN or imitator
French, 1840–1917
Bust of a Young Woman, ca. 1872–75 or
a later imitation
Terra-cotta covered with green paint
32.4 cm (12 ¾ in.)
Signed on the back at the bottom after the
firing of the terra-cotta: *RODIN*
78.SC.39

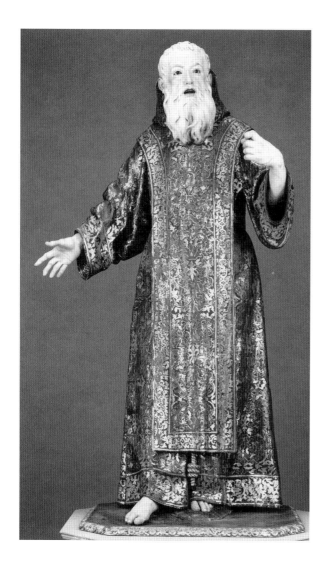

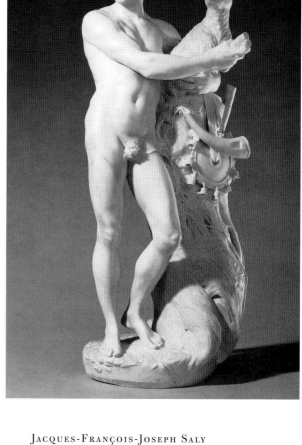

L U I S A R O L D Á N, called L A R O L D A N A
Spanish (Madrid), ca. 1655 – ca. 1704
Saint Ginés de la Jara, 169(2?)
Gilt and polychromed wood (pine and cedar) with glass eyes
175.9 cm (69 ¼ in.)
Partially obliterated inscription on the top of the base:
[LUIS]A RO[LD]AN, ESC[U]L[TO]RA DE CAMARA AÑO
169[2?]; also inscribed several times on the figure's robe: *S.*
GINES DE LAXARA
85.SD.161

J A C Q U E S - F R A N Ç O I S - J O S E P H S A L Y
French, 1717 – 1776
Faun Holding a Goat, 1751
Marble
84.1 cm (33 ⅛ in.)
Spurious signature on the base: *NL. COUSTOU FECIT 1715*
85.SA.50

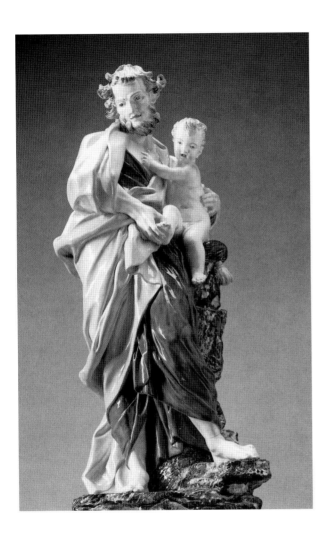

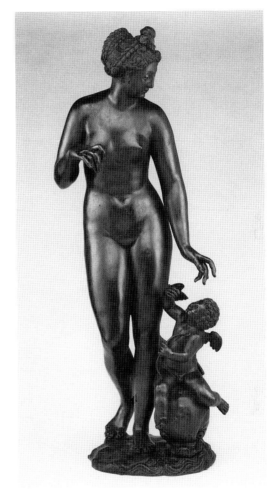

After a model by GIUSEPPE SANMARTINO
Italian (Naples), 1720–1793
Probably modeled by Gennaro Laudato
Italian (Naples), active 1790s
Saint Joseph with the Christ Child, 1790s
White-bodied earthenware (terraglia), glazed and
polychromed
54.3 cm (21⅜ in.)
91.SE.74

Circle of JACOPO SANSOVINO
Italian (active in Florence, Rome, and Venice),
1486–1570
Venus and Cupid with Dolphin, ca. 1550
Bronze
88.9 cm (35 in.)
Inscribed (probably the monogram of the founder)
under the base before casting: F^+B
87.SB.50

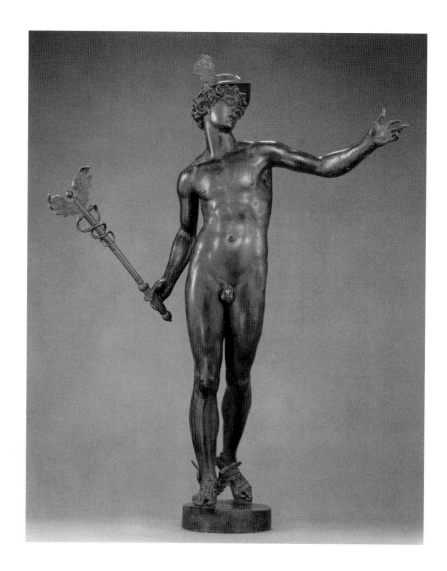

JOHANN GREGOR VAN DER SCHARDT
Dutch (active in Venice, Vienna, Nuremburg, and Denmark),
ca. 1530–1581
Mercury, ca. 1570–80
Bronze
114.9 cm (45 ¼ in.)
95.SB.8

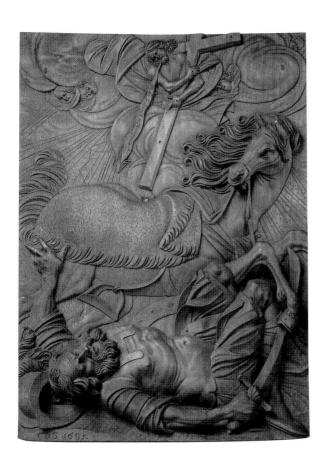

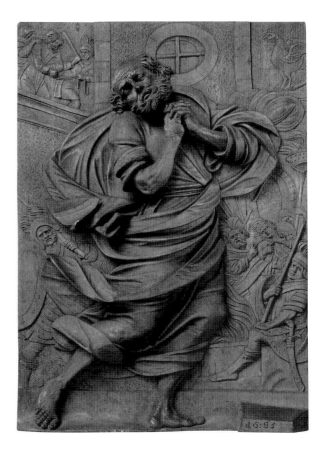

CHRISTOPH DANIEL SCHENCK
German, 1633–1691
The Conversion of Saint Paul, 1685
Limewood
36.5 × 26.7 cm (14⅜ × 10½ in.)
Monogrammed and dated at lower left: *C.D.S. 1685;* inscribed
from Acts 9:4 on the arrow emanating from Christ's mouth: *Saule
Saule, quid me persqueris?* (Saul Saul, why are you persecuting me?)
96.SD.4.1

CHRISTOPH DANIEL SCHENCK
German, 1633–1691
The Penitent Saint Peter, 1685
Limewood
36.5 × 26.7 cm (14⅜ × 10½ in.)
Monogrammed and dated at lower right: *C.D.S.
1685*
96.SD.4.2

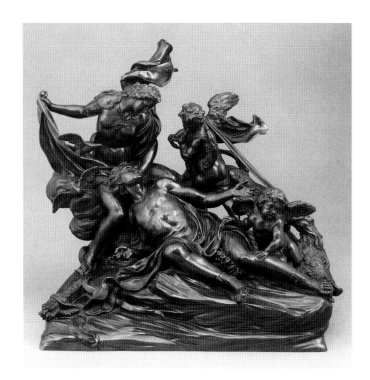

MASSIMILIANO SOLDANI BENZI
Italian (Florence), 1656–1740
Venus and Adonis, ca. 1715–16
Bronze
46.4 cm (18 ¼ in.)
93.SB.4

BERNARDO STROZZI (see FANELLI)

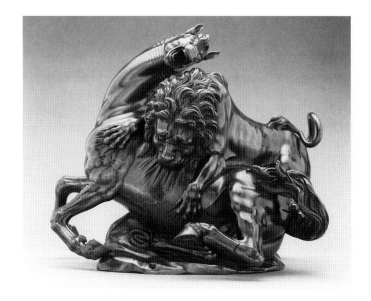

ANTONIO SUSINI
Italian (Florence), active 1572–1624
or GIOVANNI FRANCESCO SUSINI
Italian (Florence), ca. 1585–ca. 1653
After a model by Giambologna
Italo-Flemish (born in Douai, active mainly in
Florence), 1529–1608
Lion Attacking a Horse, first quarter of the
seventeenth century
Bronze
24.1 cm (9 ½ in.)
94.SB.11.1

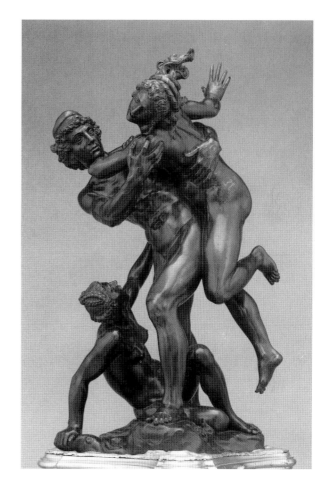

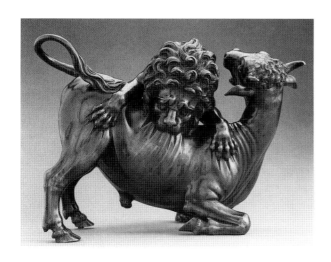

Antonio Susini
Italian (Florence), active 1572–1624
or Giovanni Francesco Susini
Italian (Florence), ca. 1585–ca. 1653
After a model by Giambologna
Italo-Flemish (born in Douai, active mainly in Florence),
1529–1608
Lion Attacking a Bull, first quarter of the seventeenth
century
Bronze
20.3 cm (8 in.)
94.SB.11.2

Giovanni Francesco Susini
Italian (Florence), ca. 1585–ca. 1653
The Abduction of Helen by Paris, 1627
Bronze on an eighteenth-century gilt-bronze base
68 cm (26¾ in.), with base
Inscribed on the base: *IO.FR.SVSINI / FLOR.FAC. /
MDCXXVII*
90.SB.32

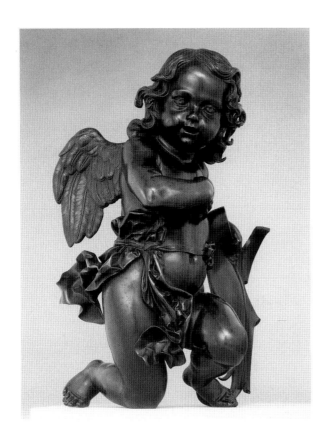

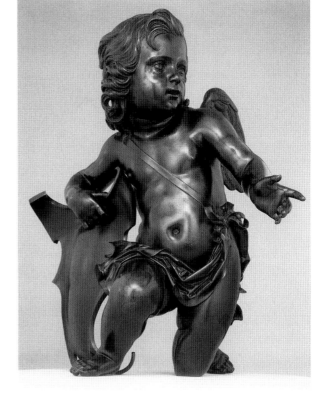

FERDINANDO TACCA
Italian (Florence), 1619–1686
Putto Holding Shield to His Left, 1650–55
Bronze
65.1 cm (25⅝ in.)
85.SB.70.1

FERDINANDO TACCA
Italian (Florence), 1619–1686
Putto Holding Shield to His Right, 1650–55
Bronze
64.5 cm (25⅜ in.)
85.SB.70.2

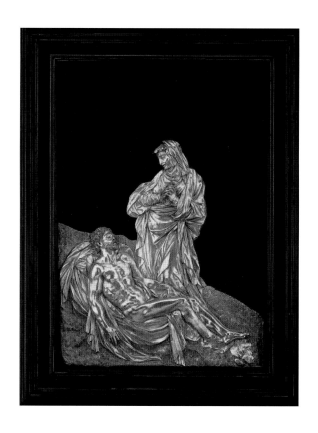

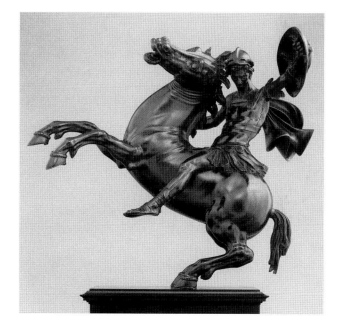

Cesare Targone
Italian (active in Rome, Florence, and Venice), active late
sixteenth century
Virgin Mourning the Dead Christ, 1586–87
Repoussé gold relief on an obsidian background
Gold relief: 28.9 × 26 cm (11⅜ × 10¼ in.)
Obsidian background: 38.4 × 26.5 cm (15⅛ × 10⁷⁄₁₆ in.)
Signed below Christ's feet: *OPUS. CESARIS. TAR. VENETI*
84.SE.121

Attributed to Willem Danielsz. van Tetrode
Dutch (active in Florence, Rome, Delft, Munich, and
Cologne), ca. 1525–ca. 1588
Warrior on Horseback (Marcus Curtius?), ca. 1560
Bronze
39.7 cm (15⅝ in.)
84.SB.90

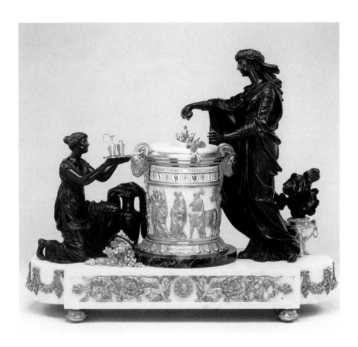

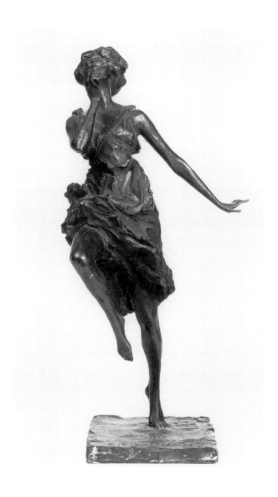

Attributed to PIERRE-PHILIPPE THOMIRE
French, 1751–1843
Dial enameled by Henri-François Dubuisson
French, active 1769–1827
Mantel Clock, ca. 1785
Gilt and patinated bronze, enameled metal, *vert Maurin des Alpes* marble
53.3 cm (21 in.)
Enameled clock ring inscribed on the interior: *Dubuisson*;
the clock's movement scratched with: *Sweden 1811*
82.DB.2

PIERRE-PHILIPPE THOMIRE (see Boizot)

PAUL TROUBETZKOY
Russian (active in Italy), 1866–1938
Dancer, 1912
Bronze
52.7 cm (20 ¾ in.)
Inscribed on the base: *Paul Troubetzkoy 1912*
79.SA.162

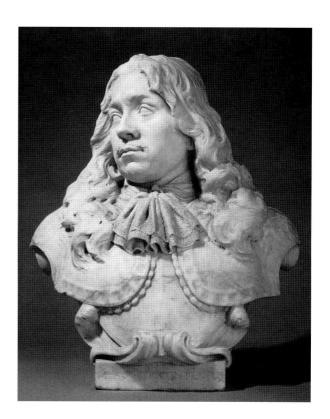

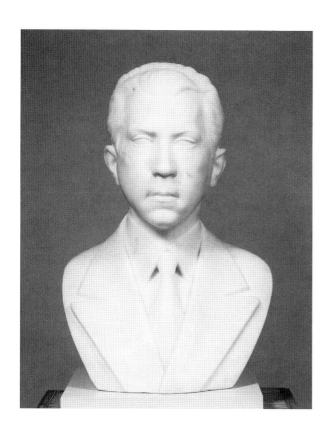

P. G. VANGELLI
Italian (Rome), dates unknown
Bust of J. Paul Getty (1892–1976), 1939
Marble
53.3 cm (21 in.)
Inscribed on the base: *SCVLTORE P.G. VANGELLI*;
on the back: *JPG Age 46, Roma, 1939.*
78.SA.40

ROMBOUT VERHULST
Dutch, 1624–1698
Bust of Jacob van Reygersberg (1625–1675), 1671
Marble
62.9 cm (24¾ in.)
Inscribed on the front: *MEA SORTE CONTENTUS*; signed
proper left: *R. Verhulst fec.*; dated proper right: *Anno 1671*;
inscribed on the back: *DIT IST HET /AFBELSTEL VAN
JACOB VAN REIGERSBERGH, /GEBOREN I
MIDDELBURGH/DEN.X.APRIL.1625./WEGENS DE
PROVINTIE/ VAN ZEELAND GEDEPUTEERD/ TER
VERGADERINGH VAN/ HAERHOOGH MOGENTHEDEN
/DEN.17.7BRE DES JAERS 1663/STURF DEN.29.APRIL.1675*
84.SA.743

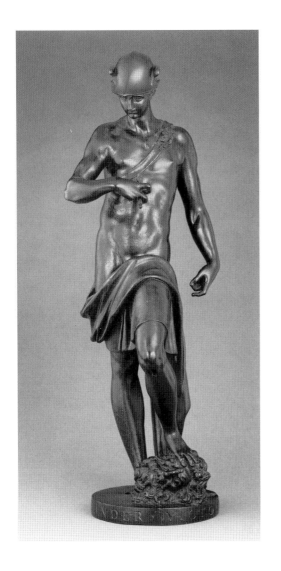

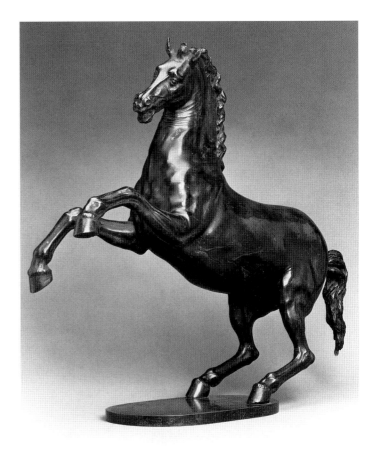

ALESSANDRO VITTORIA
Italian (Venice), 1525–1608
Mercury, 1559–60
Bronze
65.4 cm (25¾ in.)
Inscribed around the base: *ALEXANDER.*
VICTOR.T.F.
85.SB.184

ADRIAEN DE VRIES
Dutch (active in Florence, Milan, Augsburg, and Prague),
1545–1626
Rearing Horse, ca. 1610–15
Bronze
48.9 cm (19¼ in.)
Inscribed on the base: *ADRIANUS FRIES HAGUENSIS FECIT*
86.SB.488

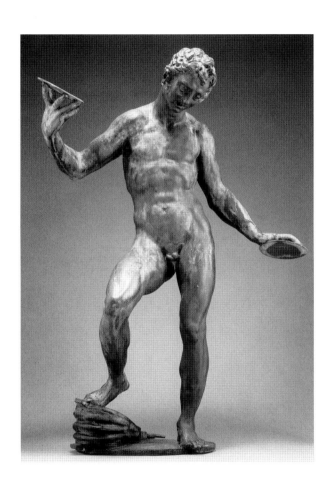

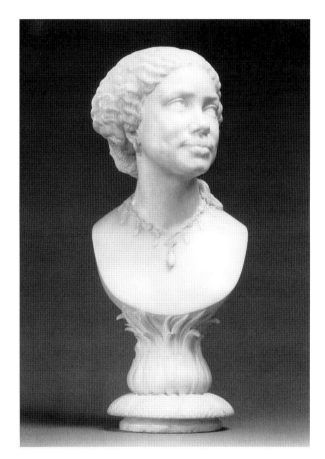

ADRIAEN DE VRIES
Dutch (active in Florence, Milan, Augsburg, and Prague),
1545–1626
Juggling Man, ca. 1615
Bronze
76.8 cm (30 ¼ in.)
90.SB.44

HENRY WEEKES, R.A.
English, 1807–1877
Bust of Mary Seacole (1805–1881), 1859
Marble
66 cm (26 in.), including socle
Inscribed: *H. Weeks A.R.A. Sc. 1859*
95.SA.82

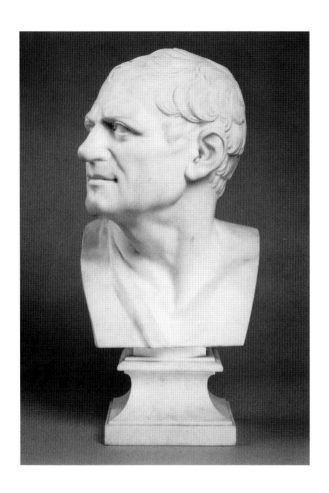

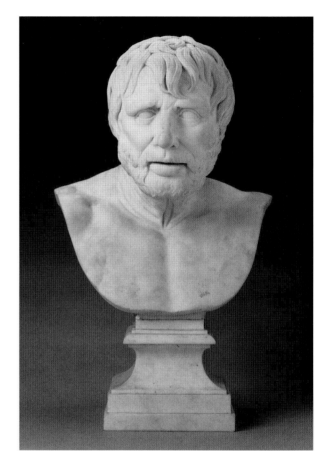

JOSEPH WILTON
English, 1722–1803
Bust of a Man (after the antique), 1758
Marble
59.7 cm (23 ½ in.), including socle
Signed and dated: *I. Wilton.fec.ˡ 1758*
87.SA.110

Possibly by JOSEPH WILTON
English, 1722–1803
Bust of Pseudo-Seneca (after the antique),
mid-eighteenth century
Marble
61 cm (24 in.), including socle
87.SA.111

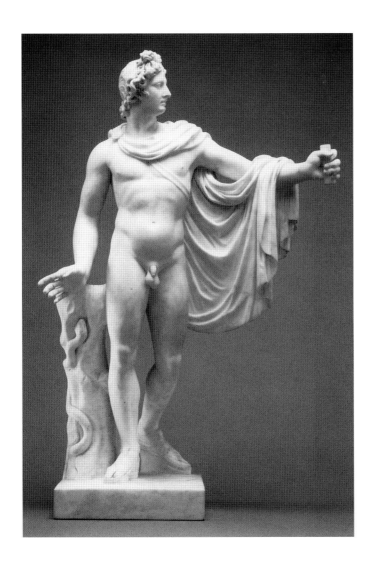

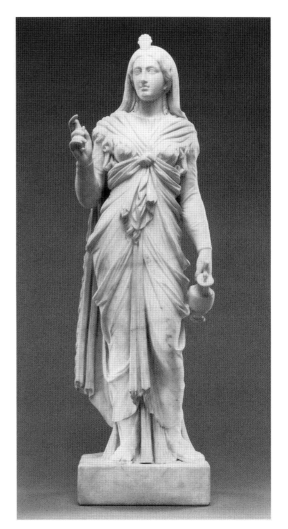

Workshop of JOSEPH WILTON
English, 1722–1803
Apollo (after the antique), 1762
Marble
75.6 cm (29 ¾ in.)
87.SA.113

Workshop of JOSEPH WILTON
English, 1722–1803
Isis (after the antique), 1762
Marble
74.9 cm (29 ½ in.)
87.SA.112

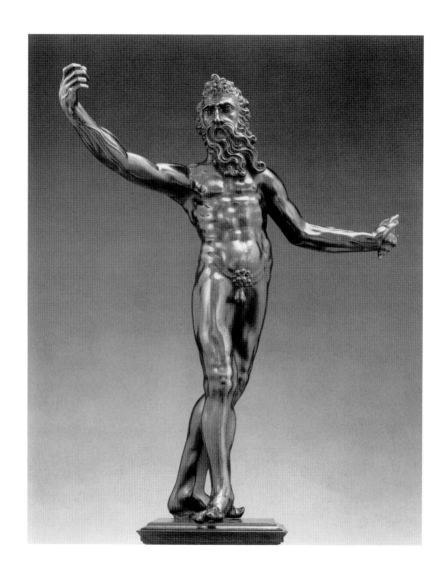

Attributed to BENEDIKT WURZELBAUER
German (active in Nuremburg), 1548–1620
Neptune, ca. 1600
Bronze
62.2 cm (24 ½ in.)
94.SB.54

Catalogue of
Unattributed Works

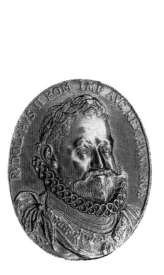

Prague
Medal of Emperor Rudolph II (born 1552, reigned
1576–1612), early seventeenth century
Gold
4.8 cm (1⅞ in.)
Inscribed on the obverse: *RVDOLPHVS II ROM IMP AVG
REX HVNG BOE*; on the reverse: *ASTRVM FLVGET CAES*
92.NJ.87
Gift of Cyril Humphris

Probably Prague
Lucretia, ca. 1600
Chalcedony
5.1 cm (2 in.)
83.AL.257.23

Corpus, 1680–1720
Boxwood figure on a later cross of oak veneered
with ebony, inlaid with brass, and adorned with
gilt-brass mounts
Height of the corpus: 48.3 cm (19 in.)
Height of the cross: 124.5 cm (49 in.)
82.SD.138

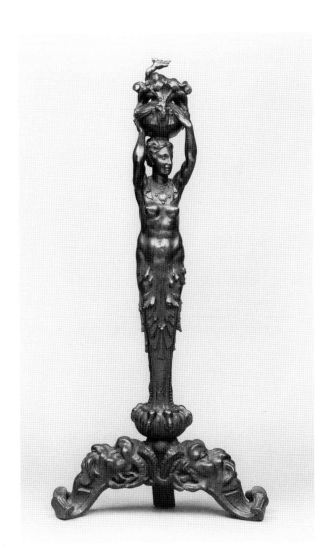

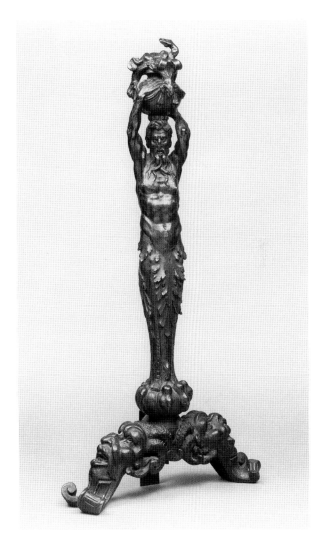

Italian artist working at Fontainebleau
Andiron in the Form of a Nymph, ca. 1540–45
Bronze
85.1 cm (33 ½ in.)
94.SB.77.1

Italian artist working at Fontainebleau
Andiron in the Form of a Satyr, ca. 1540–45
Bronze
85.1 cm (33 ½ in.)
94.SB.77.2

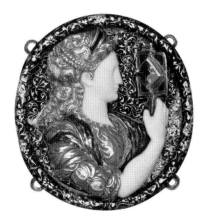

Commesso Enseigne, or Hat Badge
(representing Prudence), ca. 1550–60
Gold, enamel (white, blue, red, and black),
chalcedony, and glass in the form of a table-
cut diamond
5.7 cm (2 ¼ in.)
85.SE.238

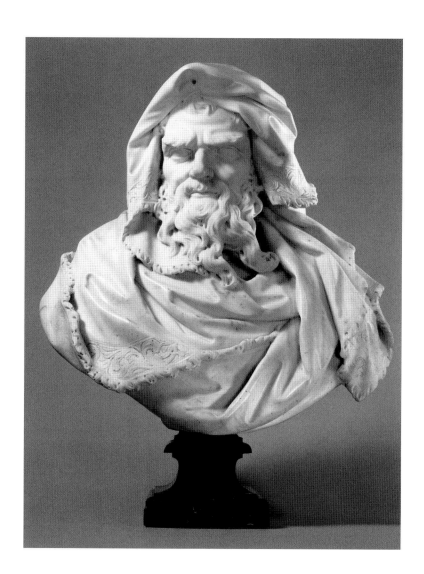

Bust of Winter, ca. 1700
Marble
65.1 cm (25 ⅝ in.), including socle
82.SA.10

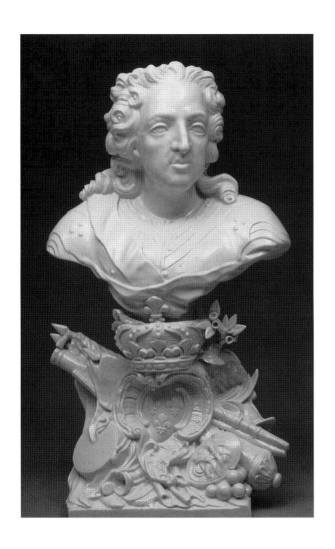

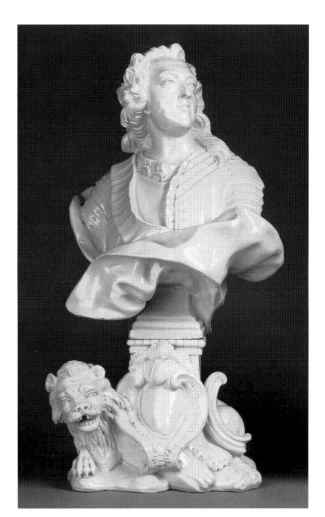

Mennecy manufactory
Bust of Louis XV (reigned 1715–1774), ca. 1750–55
Soft-paste porcelain
43.2 cm (17 in.)
84.DE.46

Lunéville manufactory
Bust of Louis XV (reigned 1715–1774), ca. 1755
Lead-glazed earthenware (*faïence fine*)
42.9 cm (16⅞ in.)
86.DE.688.1

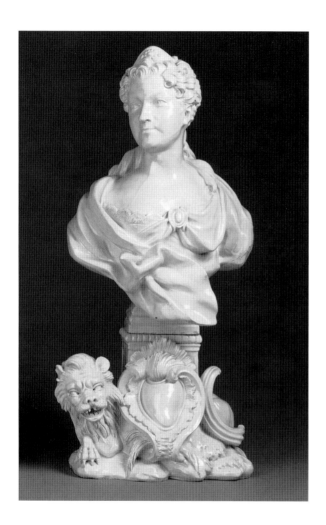

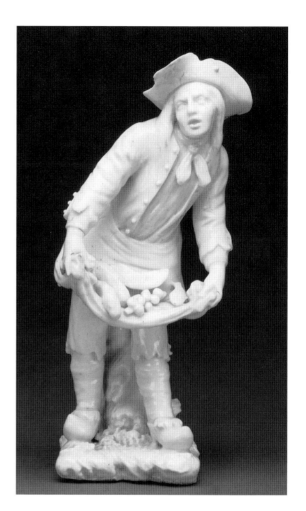

Lunéville manufactory
Bust of Marie, Queen of France (born Maria
Leszczyńska, 1703–1768), ca. 1755
Lead-glazed earthenware (*faïence fine*)
32.7 cm (12⅞ in.)
86.DE.668.2

Mennecy manufactory
Figure of a Street Vendor, ca. 1755–60
Soft-paste porcelain
23.9 cm (9⅜ in.)
Impressed on the right side of the base with the
Mennecy manufactory mark: *DV*
86.DE.473

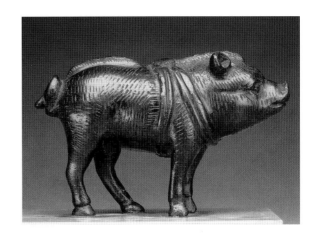

Young Boar, sixteenth or seventeenth century
Bronze
Length: 3.8 cm (1½ in.)
85.SB.71

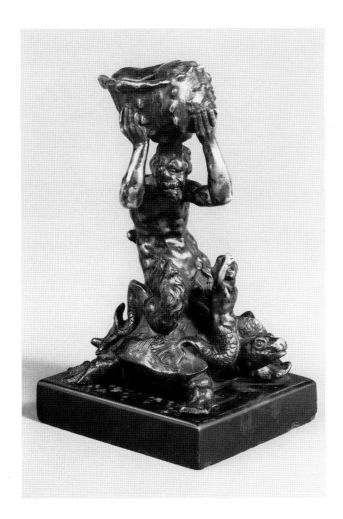

Triton Riding a Tortoise, nineteenth century
(probably an imitation of a sixteenth-century work)
Bronze
22 cm (8⅝ in.)
85.SB.67

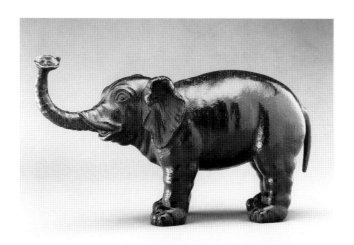

Elephant, sixteenth century
Bronze
12.1 cm (4¾ in.)
85.SB.64

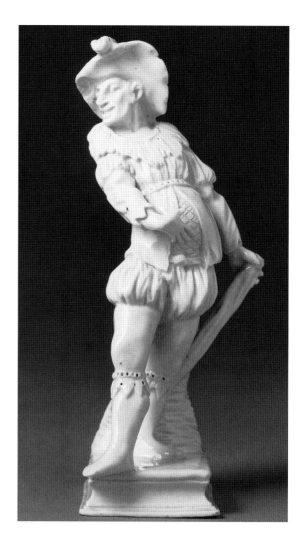

Meissen manufactory
Male Figure (probably *Beltrame di Milano*),
ca. 1720
Hard-paste porcelain
16.5 cm (6½ in.)
86.DE.542

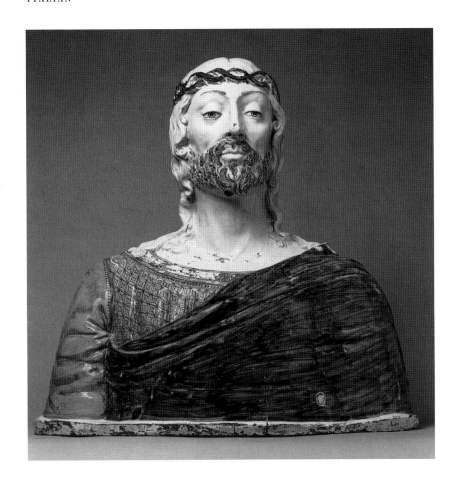

Faenza or Florence
Ecce Homo, ca. 1500
Tin-glazed earthenware
60.3 cm (23¾ in.)
87.SE.148

Padua or Venice
Bull with Head Lowered, ca. 1510–25
Bronze
12.4 cm (4⅞ in.)
85.SB.65

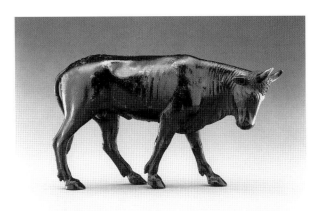

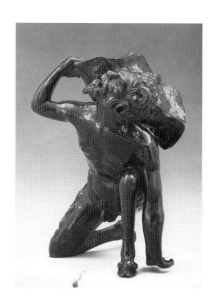

Probably Padua
Kneeling Satyr, sixteenth century
Bronze
14 cm (5 ½ in.)
85.SB.63

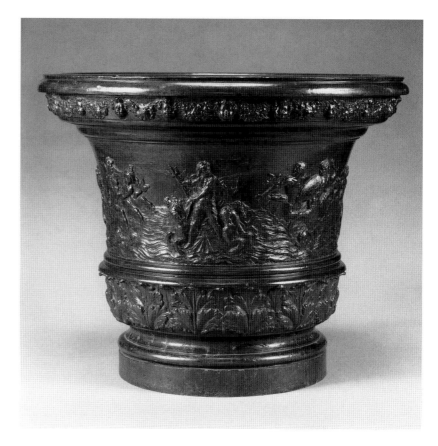

Probably Venice, possibly Padua
*Mortar Decorated with the Marine Deities Neptune
and Amphitrite and with Other Sea Creatures*, ca. 1550
Bronze
48.9 cm (19 ¼ in.); diam. at the top: 59.7 cm (23 ½ in.)
85.SB.179

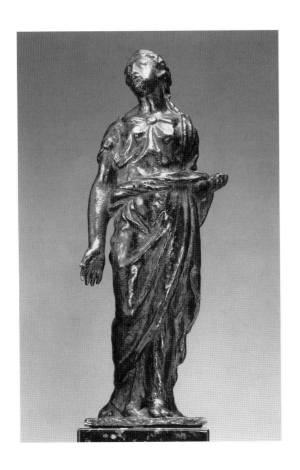

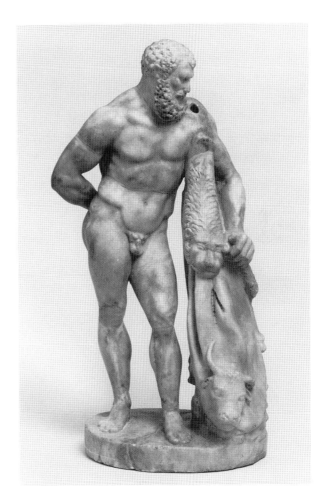

Venice
Female Figure (probably *A Virtue*),
sixteenth century
Bronze
16.2 cm (6⅜ in.)
85.SB.68

Possibly Milan
Hercules Resting
(a variant of the antique *Farnese Hercules*),
sixteenth century
Marble
34.9 cm (13¾ in.)
78.AL.49

Rome
Ducat, sixteenth century
Gold
Diam: 2.5 cm (1 in.)
93.NJ.53
Gift of Joel Malter

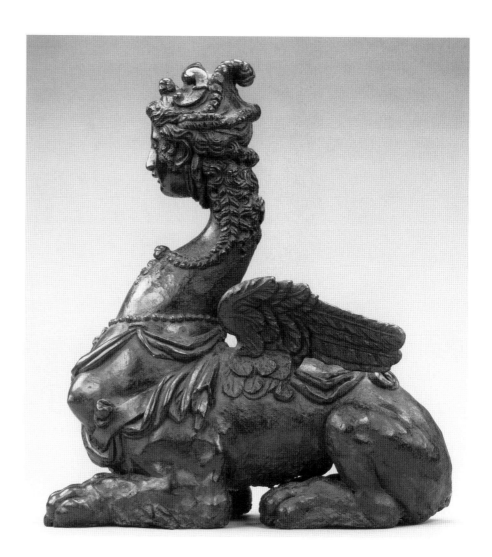

Florence
Sphinx, ca. 1560
Bronze
65.1 cm (25 ⅝ in.)
85.SB.418.2

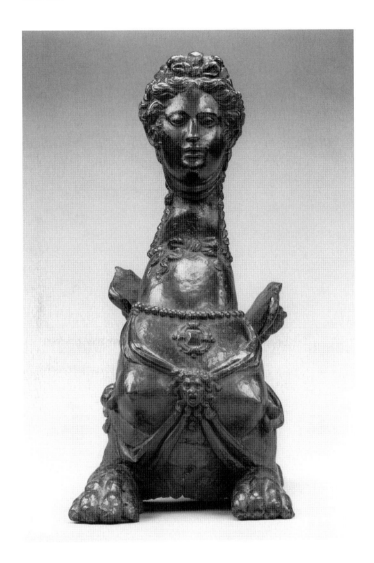

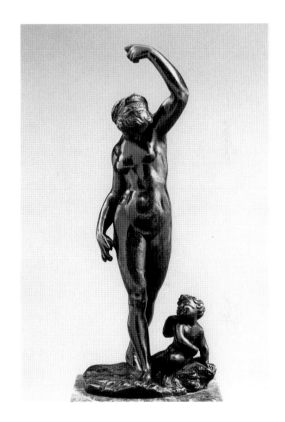

Florence
Sphinx, ca. 1560
Bronze
64 cm (25 ³/₁₆ in.)
85.SB.418.1

Probably Venice
Venus Chastising Cupid, ca. 1550–1600
Bronze
24 cm (9 ⁷/₁₆ in.)
85.SB.66

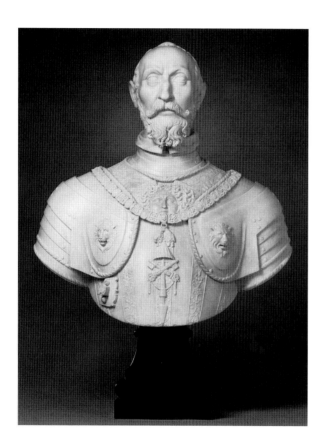

Possibly Parma
Bust of Ottavio Farnese (1542–1586),
late sixteenth century
Marble
68.6 cm (27 in.)
87.SA.36

Florence
Bust of the Emperor Commodus (after the antique;
reigned A.D. 180–192), second half of the sixteenth century
Marble
92.4 cm (36⅜ in.), including socle, which may not be
original to the bust
92.SA.48

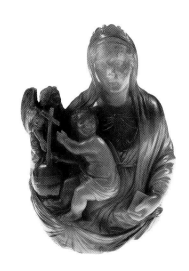

Probably Florence
Dog, ca. 1600
Bronze
30.5 cm (12 in.)
85.SB.5.1

Probably Florence
Bear, ca. 1600
Bronze
29.5 cm (11⅝ in.)
85.SB.5.2

Probably Milan
Madonna and Child,
seventeenth century
Chalcedony
15.2 cm (6 in.)
84.SA.666

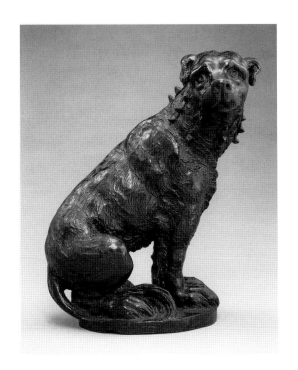

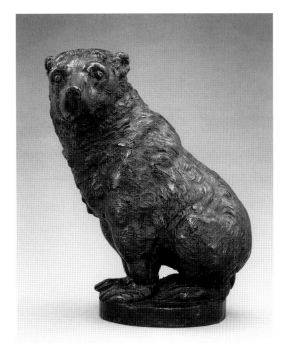

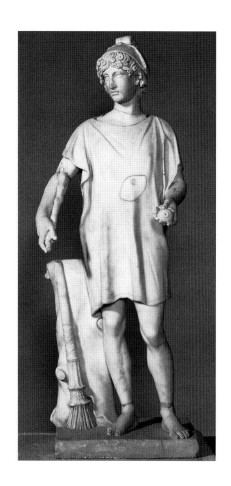

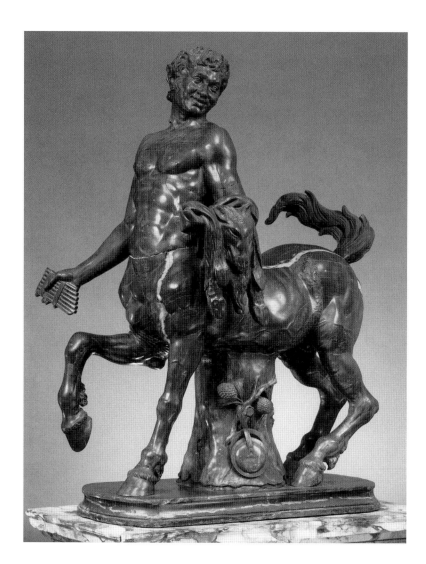

Rome
Paris, eighteenth-century (before 1767),
fake of an antique
Marble
133 cm (52⅜ in.)
Inscribed on the back of the tree stump: *48*
• I • B •
87.SA.109

Rome
Centaur (imitation or partial restoration of an antique), ca. 1775
Rosso antico, Breccia, and other types of marble
154 cm (60⅝ in.)
82.AA.78

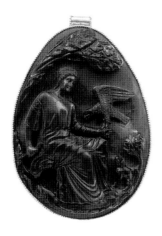

Florence (?)
Pendant Depicting a Seated Female Figure Holding a Falcon, nineteenth-century imitation of a thirteenth-century work (Hohen-Staufen style)
Heliotrope mounted in gold
9 cm (3 9/16 in.)
85.SE.54

Probably Naples
Prancing Bull, nineteenth-century fake of an antique
Bronze with silvered eyes
11.4 cm (4 ½ in.)
85.SB.8.61

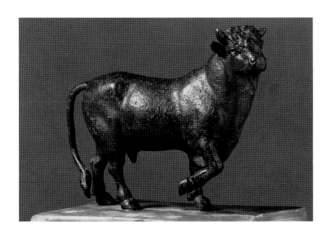

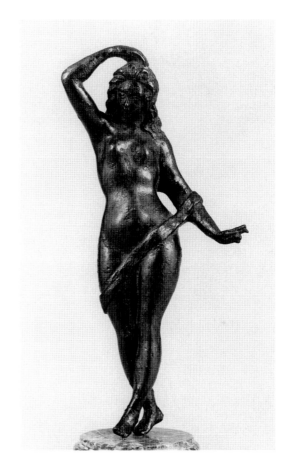

Florence (?)
Venus, nineteenth century (probably made in imitation of a Renaissance work)
Bronze
30 cm (11 13/16 in.)
85.SB.60

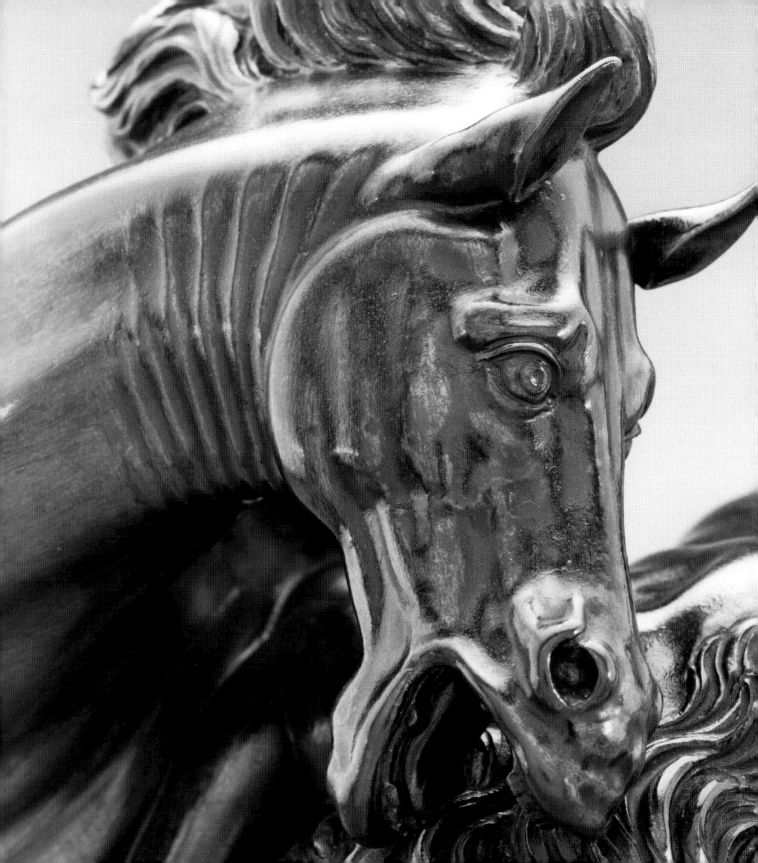

Subject Index

Numbers refer to pages.